THE ART OF HUMANISM

OTHER WORKS BY KENNETH CLARK

The Gothic Revival
Landscape into Art
Leonardo da Vinci
Leonardo da Vinci Drawings at Windsor Castle
Piero della Francesca
The Nude
Looking at Pictures
Ruskin Today
Rembrandt and the Italian Renaissance
Civilisation
The Romantic Rebellion
Another Part of the Wood
The Other Half
An Introduction to Rembrandt
Moments of Vision

THE ART
OF HUMANISM

KENNETH CLARK

ICON EDITIONS

1817

HARPER & ROW, PUBLISHERS, New York

Cambridge, Philadelphia, San Francisco,
London, Mexico City, Sao Paulo, Sydney

THE ART OF HUMANISM. Copyright © 1970, 1981 by Kenneth Clark.
Introduction © 1983 by John Walker. All rights reserved. Printed in Great
Britain. No part of this book may be used or reproduced in any manner whatsoever
without written permission except in the case of brief quotations embodied in
critical articles and reviews. For information address Harper & Row, Publishers,
Inc., 10 East 53rd Street, New York, N.Y. 10022.

FIRST U.S. EDITION

ISBN: 0-06-430861-8 83 84 85 86 10 9 8 7 6 5 4 3 2 1
ISBN: 0-60430125-7 pbk 83 84 85 86 10 9 8 7 6 5 4 3 2 1

LIBRARY OF CONGRESS CATALOG CARD NUMBER: 82-48689

CONTENTS

Introduction by John Walker 7

1

DONATELLO AND THE TRAGIC SENSE
IN THE QUATTROCENTO
Page 11

2

PAOLO UCCELLO
AND ABSTRACT PAINTING
Page 43

3

LEON BATTISTA ALBERTI
ON PAINTING
Page 79

4

MANTEGNA
AND CLASSICAL ANTIQUITY
Page 107

5

BOTTICELLI'S
ILLUSTRATIONS TO DANTE
Page 141

List of Plates 181

Index 185

TO MY STEPDAUGHTER
ANGELIQUE
WITH LOVE

INTRODUCTION

This book had an immediate, if unexpected effect on me. It roused an instant urge to go once more to Italy to appreciate with new enjoyment all that Kenneth Clark so perceptively examines for us. This reaction was somewhat surprising since I had spent eight years in Florence and Rome, three of these with Bernard Berenson at his villa, I Tatti, where I followed Kenneth Clark who had left to become Keeper of the Department of Fine Arts at the Ashmolean Museum, Oxford. This was the beginning of his extraordinary career, during which he held many offices, among them Director of the National Gallery, Surveyor of the King's Pictures, Slade Professor at Oxford, Chairman of the Arts Council, Chairman of the Independent Television Authority, Chancellor of the University of York, and then the role for which perhaps he is most famous—the protaganist of the peerless television show, *Civilisation*.

While I was living in Italy I was preoccupied with the works of art described and analysed in this book; but to my amazement Kenneth Clark has found marvels I missed. At the end of each chapter I wondered how I could have been so blind, for he has made me see everything afresh. I now look forward to revisiting those churches and palaces I thought I knew so well; and, improbable as it is for one who hates and fears Communism as I do, to cross into East Germany to see the originals of Botticelli's illustrations to Dante. I can give the author no higher praise.

I am sure the average reader will be equally spellbound. Alberti's architecture is doubtless familiar to him, but what does he know of the first treatise on the art of painting which Alberti completed on the 26th of August 1435 and which was destined to exert such an important influence on Florentine artists? Donatello's statues are part of the visual

imagery latent in all our minds when we think of Renaissance art, but how carefully have we looked at his amazing reliefs, infused as they are with the inescapable tragedy inherent in human life? Paolo Uccello has always been accepted as a master of quattrocento perspective, but his passion for mathematical and geometrical depth, Kenneth Clark points out, gives him a relationship to Seurat and makes him a precursor of the Abstractionists; and Mantegna, so obviously the reviver of classical antiquity—how little have we considered him as an ardent and devout Christian painter with a vein of tenderness quite unexpected. Botticelli, whom Berenson termed 'the greatest artist of linear design that Europe ever had' and once possessed of a reputation to be conjured with, has along with his contemporaries, passed into the 'limbo of reaction', to use Kenneth Clark's phrase. Sir Edmund Gosse, at one time the undisputed *Eminence* of English culture, told Kenneth Clark: "The name of Botticelli was the key to the most select society in England." He had not seen much of the artist's work he admitted, but Gosse 'was not a man to neglect a key'. And then Kenneth Clark adds, 'I am afraid it would not open many doors today'. To this I cannot but assent.

Italian fifteenthcentury art needs an apologist like Kenneth Clark. He has shown in this book the dazzling merit, intellectual and artistic, of the five artists he discusses, five masters of humanistic architecture, sculpture, and painting. Their humanism he defines as an ardent belief in the greatness of man and the supremacy of human values. This is expressed by Donatello when he carved the statue of St Mark for Or San Michele, revealing in it his ideal of a 'serious, responsible, and noble human being'. Gravity and dignity, which we find in this statue and in so much of quattrocento art, are the core of humanism.

It is difficult to describe the magic of Kenneth Clark's writing. In these essays we find what we expect from him: erudition, insight, perception. But one is unprepared for the rarest of all qualities in art historical studies—humour. There are startling and amusing comparisons. For

example, of Alberti's rather boring *della Pittura* he writes: 'There are times when the image of a bland old gentleman in a wig giving away prizes to successful students entirely supersedes that of the taut and fiery Florentine.' And here is one of his arresting similes: when describing the lamentable repainting of Mantagna's *Triumphs* he tells how this was done at one time by Paul Nash under the guidance of Roger Fry with the result that the paintings 'had a flavour of the 1920s almost as strong as *The Boy Friend*'. Welcome as are such comparisons they are infrequent in art historical studies.

Kenneth Clark is never pedantic, and this is in itself a delight, for pedantry is one of the afflictions of most authors of erudite studies like these. Also few scholars of art history know how to write, or give the slightest thought to style, or even to helping the reader with lucid exposition. What a joy it is to read eloquent English prose, describing some of the greatest works of art ever created. For those of us condemned to study innumerable pages of art history Kenneth Clark's books are a cool and refreshing oasis in a parched and arid desert. We are grateful to him. He is a civilised human being. If only he were not so unique among art historians!

JOHN WALKER
Director Emeritus, National Gallery of Art, Washington D.C.

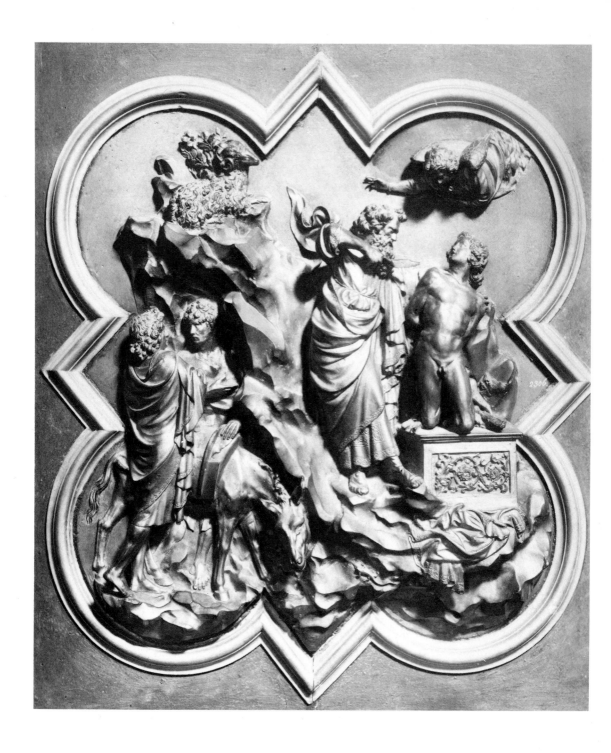

1 Lorenzo Ghiberti, *Abraham sacrificing Isaac*, 1401–02

DONATELLO AND THE TRAGIC SENSE IN THE QUATTROCENTO

In the early fourteenth century the Florentines were a profoundly serious people: serious about business, serious about family politics, serious about the relations of man to his creator and to the whole cosmological scheme. The two greatest Florentines of the time expressed this seriousness in two different ways, Dante through the fierce moral judgements which appear on every page of the *Inferno*, the first twenty cantos of the *Purgatorio*, and the theological expositions of the *Paradiso*, Giotto through a sense of human drama which has never been surpassed. They were antithetical. Dante belonged to the old world of scholastic philosophy; Giotto to the new world of banking and industry. But they were united by their sense of the dramatic relationship of human beings to one another. In Giotto's fresco of the Betrayal in the Arena chapel the contrast between the severity of Christ's gaze, and dawning consciousness of guilt in the almost sub-human Judas, is drama of the highest order. When did this serious attitude towards human life die out? The answer is, during the lifetime of Giotto himself. His later works—his signed and documented works—are decorative. Even the Stefaneschi altarpiece specially commissioned for the high altar in St Peter's, has an entirely different character from the dramatic frescoes. Since cleaning it has revealed the rich, decorative colour of an enamel. It is a joy to the eye, but we do not look first at the

human content. After Giotto there was a period of exhaustion. In one of Sacchetti's *Novelle* the printer Taddeo Gaddi says 'This art has grown, and continues to grow, worse day by day'.

The staleness of Florentine art in the late fourteenth century was relieved at the end of the century by an artist whom I think is still underrated, Lorenzo Monaco. A beautiful stylist: but still primarily a stylist, whose flowing line was used chiefly to depict the more lyrical episodes in the Gospels or the lives of the Saints. The sense of human drama, the feeling of tragedy, hardly ever appears. When does it reappear? In 1401, when the Arte di Calimala announced the terms of a competition for a second bronze door for the Florentine Baptistry.

The Ghiberti relief [1] is an amazingly accomplished piece of work. It is dominated by a strong, vital rhythm, which forces us to concentrate on the terrible subject; it includes a nude figure *a l'antica* which might have been designed a century later; it is executed with a fine craftsmanship, learnt from Burgundian goldsmiths which was never to be surpassed in Florence. It is above all a masterpiece of *style*. By comparison the Brunellesco [2] lacks a unifying rhythm; in fact the composition is rather awkward. *But* when one concentrates on the heads of Abraham and Isaac one finds something that Ghiberti never quite achieved: an intensity of purpose, and a feeling that men's relations with God and with each other is a terrible, and ultimately a tragic, responsibility.

This is the source of Donatello, who was seventeen years old at the time, and the fact that he was trained in the workshop of Ghiberti never deflected him. Not that Ghiberti was incapable of human feeling. But style came first. To take an example from the second doors, that masterpiece of space-composition in which we seem to breathe so freely, the Jacob and Esau [3]. No doubt that the encounter of Jacob and Esau is deeply felt and extremely touching. But it is put away in the corner of the composition, in which the figures are so elegantly distributed. Most people don't notice the detail of Jacob and Esau at all.

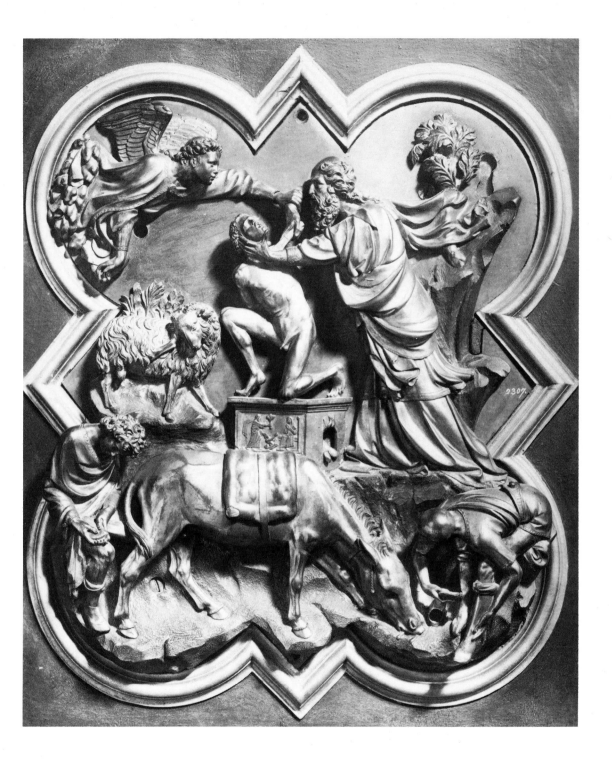

2 Filippo Brunellesco, *Abraham sacrificing Isaac*, 1401–02

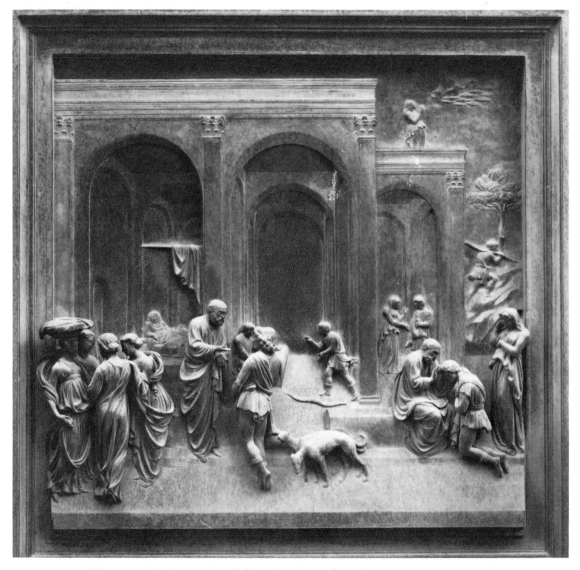

3 Lorenzo Ghiberti, *Jacob and Esau*: panel from the *Gates of Paradise*, *c.* 1435

4 Donatello, *St Mark*, 1411–13

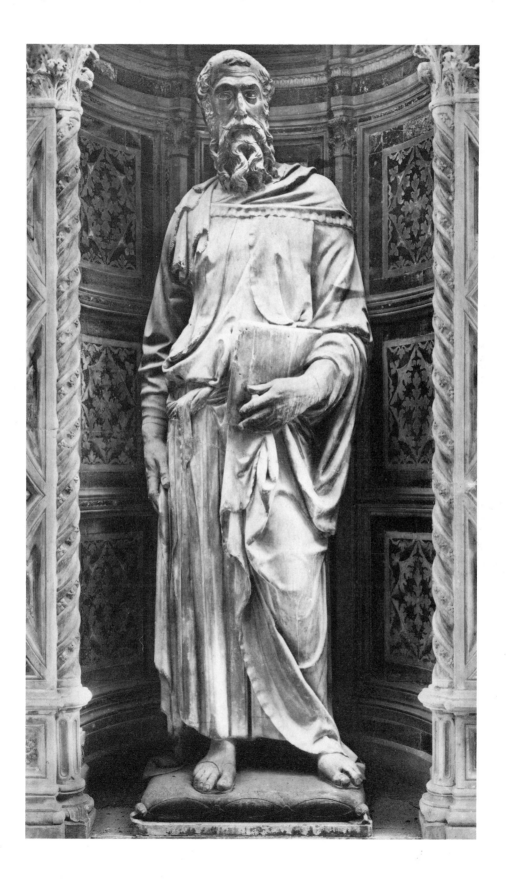

Ghiberti's love of style for its own sake, which perhaps he first developed during a visit to Paris or Burgundy about 1400, never left him; and we have a curious example of it in the bands of floral ornament which run around the panels of the second doors. They show that he has not been able to resist a fashion that was then reaching its zenith in Flemish illuminated MSS; and you will remember that a year before he began work on the second doors (1424) Gentile de Fabriano had completed the most fashionable and most influential of all paintings of the early *quattrocento*, the *Adoration of the Magi* painted for S.ta Trinita. No painter had ever been more successful than Gentile. In Florence, in Venice, in Rome, his charming version of the so-called International Gothic style was irresistible. It was originally an aristocratic style, but it appealed equally to bourgeois societies, and it created a tone that continued throughout the *quattrocento*. What prevented this style from having a monopoly in Florence? The answer can be given in three words, Or San Michele. This chapel of the Guilds of Florence became in the first thirty years of the *quattrocento* the bastion of *le bon serieux Florentin*. It was here that in 1411 Donatello (aged 25) carved the first figure which reveals his ideal of a serious, responsible and noble human being, his *St Mark* [4]. We cannot forget Michelangelo's comment 'No one could doubt the Gospel of Christ preached by so sincere a man'. The benign humanity of the *St Mark* was succeeded by the far more powerful psychological studies of the four prophets on the campanile of the Duomo. The first was begun in 1415, and Donatello kept on working at them for almost twenty years. It was as if he could not bring himself to say goodbye to these four companions who had become so much the embodiment of his own meditations on human destiny. We have no difficulty in believing the story that he was overheard saying to the prophet known as the Zuccone [5] 'Speak, damn you, speak'. In fact the prophet has his mouth open, but, although we seem to have known him all our lives, we have no idea what he is going to say to us. From one aspect he is stern, from another

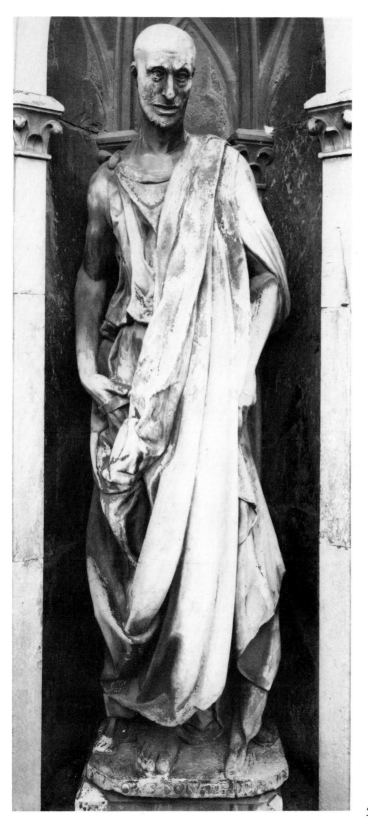

5 Donatello, *Zuccone*, 1423–25

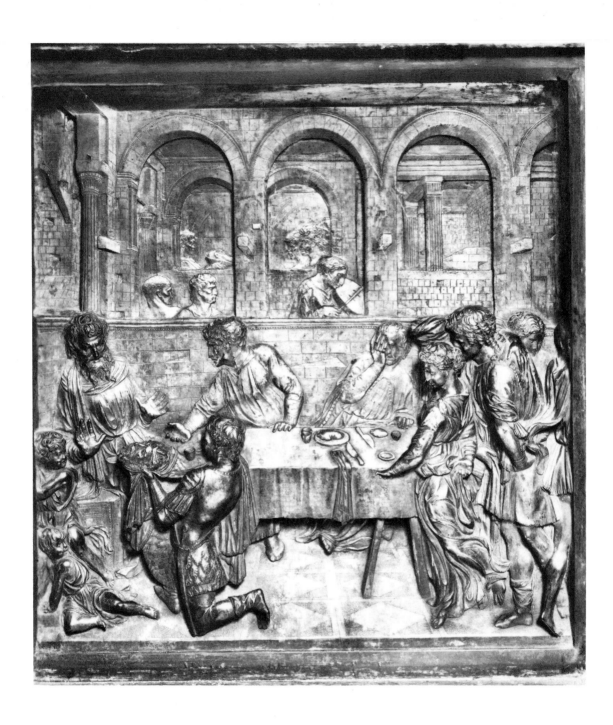

6 Donatello, *Feast of Herod, c.* 1425

forgiving, from one aspect a powerful bailiff, from another a prophet.

'Speak, damn you, speak' comes from Vasari. He also tells us that when the *St Mark* of Or San Michele was seen by the wardens on the ground, it was nearly rejected, whereupon he had it, at his own expense, put up in its niche, and when it was unveiled everyone agreed that he had wrought most extraordinary changes on it. He repeats the same story apropos of the nose of Michelangelo's *David*. They may both have been true! The Prophets on the campanile were to an even greater extent designed to be seen from below. Now that they have been placed at eye level in the Museo del Opera del Duomo they have lost some of their force. John Pope-Hennessy has finely described their original effect: 'To the spectators who looked up at them the four prophets, one meditating silently upon the crowd below, another moving forward about to speak, the third reading from his scroll, and the fourth exclaiming with parted lips, opened the way to a new imagery in which persons from the Old and new Testament were presented for the first time as real figures with a liveliness more vivid than life itself'. In short, the ancestors of Rembrandt.

The Prophets are the spectators of tragedy, not the protagonists. But during the years in which they were his companions he executed his first tragic scene, a gilt bronze relief in the Baptistry of Siena representing the presentation of the Baptist's head to Herod [6]. The relief was designed in 1425 and cast before 1427. Although Donatello had already invented, and in one amazing leap forward perfected, the new medium of low relief in the predella of the *St George* at Or San Michele, the front of Siena demanded high relief, which allowed less room for Donatello's dramatic sense to expand and develop, as it was to do in the reliefs of the Santo. But what an appalling drama it is. The horror of Herod, and the physical disgust of the man seated to the right of the table, are contrasted with the encouraging gesture of the other figure. Herod and the horrified man are real human beings. One need only compare the relief with a painting of the same subject by Giovanni di Paolo, which is probably inspired by the

Donatello, to realise the gulf between Gothic illustration, however vivid, and a serious awareness of the whole human drama.

At this point we must consider Masaccio. He was fifteen years younger than Donatello, and so only a child when what might be called the Or San Michele style was bringing Florentine art back to realities. But by the age of 25 his prodigious talents were already apparent. Because he was the first great Florentine painter since Giotto, earlier critics used to speak of him as a sort of *Giotto redivivus*. But although he reaffirmed the grand plastic forms of Giotto, his imagination was of a different order. He thought in terms of classical idealism. His figures are noble, silent, controlled by a sense of high purpose. He would never have painted Giotto's *Marriage of Cana*, or even his *Nativity*. His true successor was not Masolino, but Raphael of the tapestry cartoons.

There is (for once) documentary evidence that he became a close friend of Donatello, and depended on him not only for inspiration but for guarantees of money (because Masaccio was always hard up). And personally I am convinced by the theory that Donatello's relief of the *Ascension and Delivery of the Keys* [7] in the Victoria and Albert Museum was originally on the altar of the Brancacci Chapel. The Christ and the kneeling Virgin are Masacciesque. But when one comes to the groups of apostles either side, what a contrast with the solemn, silent company of the *Tribute Money* [Alberti 2] are these vivid, curious and highly individualised figures, who anticipate the argumentative animation of the Padua predella. However, we must allow that Masaccio created one of the greatest tragic images of western art, one which Donatello did not equal till the last years of his life, the *Expulsion of Adam and Eve from Paradise* in the Carmine.

If Masaccio had lived the theme of this essay would have been totally different. He so obviously surpassed all the painters of grace and sweetness—Gentile, Fra Filippo, even Beato Angelico—that Florentine art of the *quattrocento* would surely have taken a different direction. But

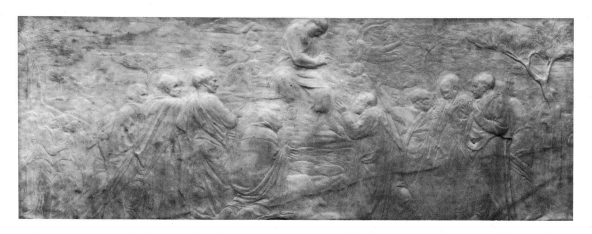

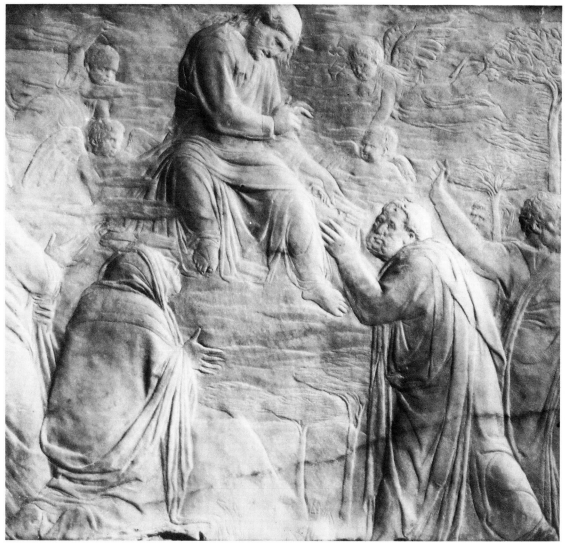

7 Donatello, *Ascension with Christ giving the Keys to St Peter, c.* 1430, and detail

Masaccio died in 1428, three years older than Keats. I believe that his death had a profound effect on Donatello. He felt himself to be isolated, and during the next decade he undertook no great dramatic themes, but occupied himself chiefly with the decoration of the old sacristy of S. Lorenzo. It is an example of our ignorance of the past that we have no documents for the building and decoration of what is arguably the most beautiful, certainly the richest interior of the mid-fifteenth century. But early sources, not only Vasari, but the reliable Manetti, leave us in no doubt that it ended in a quarrel between Donatello and Brunellesco. They had been, says Vasari, *amicissimi*. But when Donatello, by the architectural surrounds of his bronze doors, compromised the purity of Brunellesco's architecture, the quarrel broke out, and Brunellesco wrote a series of lampoons, some of which, says Manetti, in 1475 'are still in circulation', charging Donatello with arrogance, and ignorance of architecture. I believe that this quarrel between the two greatest artists in Florence was largely responsible for Donatello's staying on in Padua, after he had executed the Gattamelata. And in the very year that Donatello had left Florence Brunellesco took over Bernardo Rossellino, who must surely have designed the architectural elements of the monu- ment to Leonardo Bruni—a profoundly un-Donatellesque design. For the rest of his life (he died before Donatello's return from Padua) he seems to have been the controlling mind behind such relative mediocrities as Benedetto da Majano. In their works the dramatic spirit disappeared from Florentine sculpture, and produced the kind of worthy, acceptable works of which Ghirlandaio was later to be the pictorial equivalent. Beside them was sweetness, the sweetness of Luca della Robbia, Fra Angelico and Fra Filippo: three beautiful artists, but a long way from the spirit of Dante and Giotto. And there was Uccello, once thought of as a naturalist or scientific painter, but in his chief surviving works of the '40s a sort of tapestry artist, chivalric, decorative and even further from the dramatic humanism of Donatello than Fra Fillipo. There was, of course,

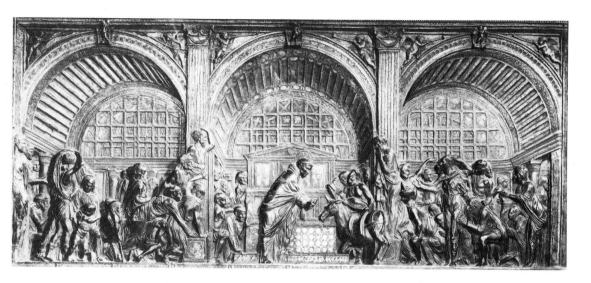

8 Donatello, *Miracle of the Ass*, 1446–50
9 Donatello, *Miracle of the Irascible Son*, 1446–50

one exception, Andrea del Castagno. He is the odd man out in the
Florentine *quattrocento*, as much enamoured of pain and violence as
Caravaggio or the hero of a modern play. His *Crucifixion* in S. Apollonia
is the ruin of a great picture. But his outlook (as opposed to his technique)
had no influence on Florentine art of the mid-*quattrocento*. So when
Donatello decided to stay on in Padua and work on the altar of the Santo
he may well have felt that in Florence the tide of fashion had set against
him, and although, as we know, he missed the stimulating, intellectual
atmosphere of his native town, he may have felt that in a less competitive
atmosphere he would be free to realise the tragic visions which were no
doubt already haunting his imagination.

It is somewhat ironic that the subjects on which he imposed his
dramatic turbulence were miracles performed by the sweetest and gentlest
of saints, St Anthony of Padua. They occur on what must have been a
sort of predella to the whole altar and are among the most astounding
masterpieces of mid-fifteenth century art. The Antonini are not a very
welcoming brotherhood, but with the financial resources of the B.B.C.
behind me I was able to see the reliefs by the light of television lamps, and
the beauty of the casting and chasing, with much actual gilding, is far
beyond anything that photographs can convey. Donatello has conceived
his four miracles in contrasting settings: in the miracle of the ass [8], the
crowd is confined under the splendid arches of three chapels: in the
miracle of the irascible son [9] the action takes place in the disturbing
space of an enormous stadium, lit by a fierce sun. At the centre of each
scene the saint, calm and benevolent, performs his miracle; but on either
side of him the public presses forward with hysterical curiosity, or turns
away shocked by this reversal of the common course of nature. They
climb on ledges and push each other out of the way with the violence and
variety of the great crowd scenes in an Eisenstein movie.

Somewhere in the original complex (and all reconstructions of the
Santo altar are almost equally unconvincing) was one of Donatello's

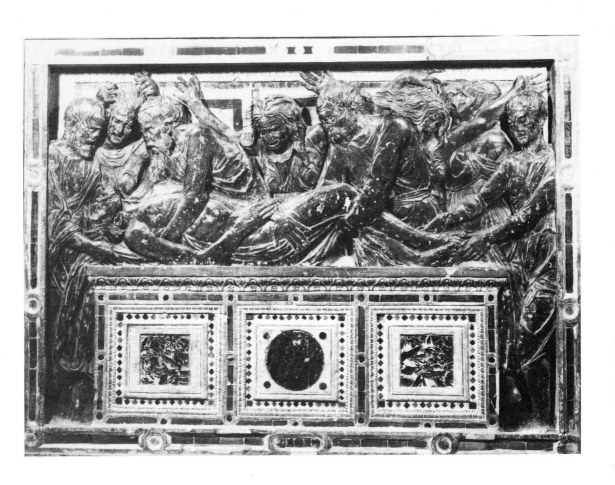

10 Donatello, *Entombment*, 1446–50

greatest tragic inventions, the *Entombment* [10]. He had realised the theme
before in the ill-designed tabernacle in St Peter's, which, to my eye,
contains an element of gothic hysteria which is foreign to him. The
Victorians were fond of the word manly, and this is one of the few works
by Donatello to which it cannot be applied; whereas the *Entombment* of
the Santo, although superficially so similar, has a controlled humanity
that is pure Donatello. The bearded men who lay the body in its tomb are
grave and solicitous; the lamenting women are crying out with grief, but
they are not hysterical.

 During his stay in Padua Donatello frequently visited Venice, and we
know him to have been in touch with the monks of the Frari. Shortly
before returning to Florence he executed for them one of the most discon-
certing of all his works, the wooden polychrome figure of *St John the
Baptist* [11]. Recent scholars have spoken of it as a new departure in his
work, a sudden turning away from the classical renaissance, a renunci-
ation of humanism. It is true that the Frari *St John* is a startling contrast to
the bronze *David*, or even to the early *St Mark*, but is he so far from the
Zuccone? Donatello always had within him a feeling for the intensity
with which human beings react to emotional forces, and there are figures
in the Padua reliefs almost as spiritually obsessed as the *St John*. Still, one
must admit that this weird, compelling figure goes further along the same
road, and there is no reason to reject the hypothesis that Donatello had
been profoundly disturbed by the horrors of 1453, a year of earthquakes,
tempests, assaults on the Pope, and finally the fall of Constantinople. He
may even have been influenced by the anti-humanist Archbishop of
Florence, later canonised as St Antonine, who, in his desire to bring
people back to true Christian values, dressed himself in rags, and walked
about the city urging them to abandon their luxurious habits: a fore-
runner of Savonarola.

 In about 1454 Donatello returned to Florence. In that year the gilding
of Ghiberti's second doors was completed, and they were unveiled in all

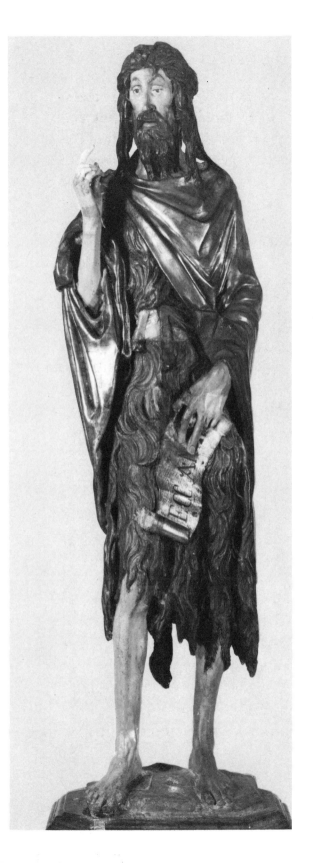

11 Donatello,
St John the Baptist, 1453–54

their elegance and shining splendour. They were the supreme example of the Florentine love of grace which had first established itself about thirty years earlier. Before going to Padua Donatello had shown himself a master of this idealised beauty in the bronze *David*, where the sensuality is almost disturbing. Perhaps the intensity of his response to physical stimulus is partly responsible for the extreme violence of his reaction. At all events, from the Frari *St John* onwards, the human body is no more than an uncomfortable lodging for the soul. During the few years after his return to Florence—1453–1456—Donatello executed some of his greatest tragic works. The most familiar and the most appalling is the *St Mary Magdalene* [12] in the Baptistry, from which we may flinch as we do from the news in the morning papers. I suppose that this was the inspiration of Rodin's *Belle Haulmière*. But the extraordinary thing about this figure is not the terrifying ugliness of old age and privation, but the real nobility that becomes apparent when we look at her in profile [13].

> The soul's dark cottage battered and decayed
> Lets in new light through chinks that time hath made

There is the greatness of Donatello. His dramatic power is always tempered by an understanding of the total complexity of human life.

The date of Donatello's *Magdalene* is a matter of controversy. Personally, I incline to think that it follows immediately on the *Baptist* in the Frari. But we have no doubt about another of the great tragic works executed after Donatello's return from Padua, the *Judith and Holofernes* [14]. This figure comes from the depths of his imagination and is a supreme demonstration of his sculptural power. *Judith and Holofernes* is often said to be the first free standing figure of the Renaissance, although there is evidence that the bronze *David* also stood by itself. The *Judith* was originally in the gardens of Cosimo de' Medici, from whence it was later moved to its present position in the Piazza della Signoria. It was intended to be seen from every angle, and sure enough, as one walks round it, one

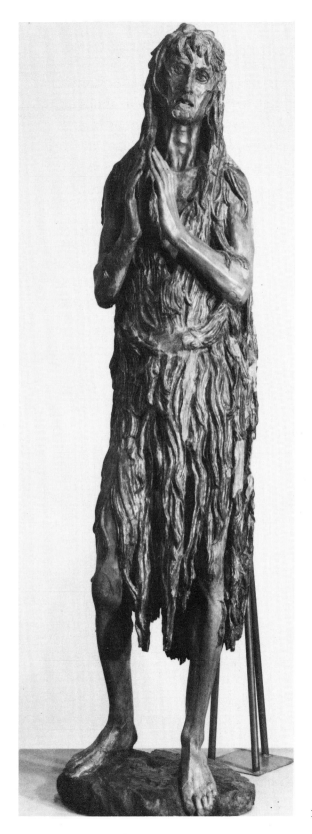

12 Donatello, *Mary Magdalene*, 1454–55

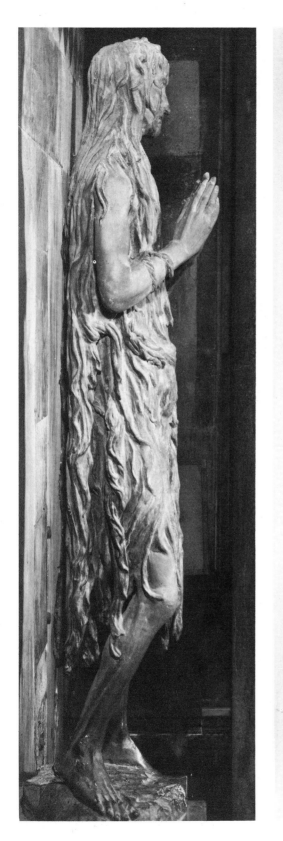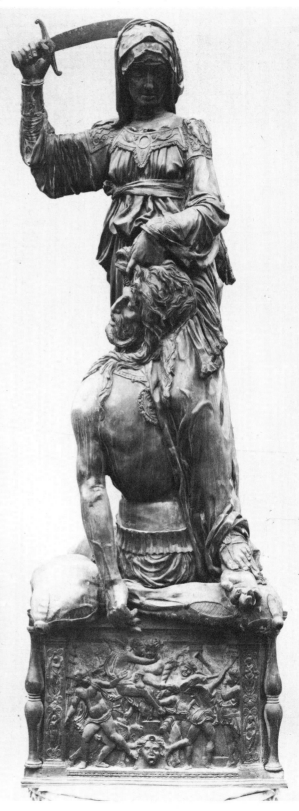

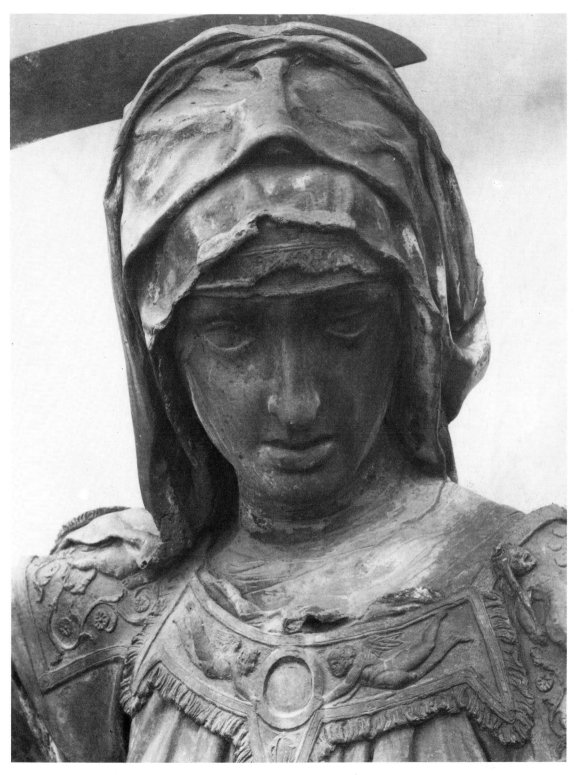

13 Donatello, *Mary Magdalene* (profile)
14 Donatello, *Judith and Holofernes*, 1456

15 Donatello, *Judith and Holofernes* (detail)

receives a fresh impact at every step. The theme, the victory of Humilitas and Sanctimonia over Superbia and Luxuria, is conceived both on a narrative and a symbolic plane; but I cannot truly say that the symbolic element seems to have greatly influenced Donatello. The *Judith* [15] does not look at all like an image of Humilitas; from certain angles she looks like an incarnation of Superbia, and the head of Holofernes has a pathos which seems to indicate where Donatello's sympathies lay. It is an incident in tragic drama done with the kind of complex impartiality that one finds in Shakespeare.

From about the same date belongs the small bronze relief in the Victoria and Albert Museum, the *Lamentation over the Dead Christ* [16]. The head of the Christ is remarkably similar to the head of Holofernes, and yet the style is not quite so rough as that of the later S. Lorenzo pulpits. This is the most moving of all Donatello's small works, tragic, passionate and yet controlled by a feeling of truth. Even Donatello never surpassed the rhythmic flow which unites the figures. If, as has been suggested, this is a demonstration piece cut from one of the wax models for the doors of Siena Cathedral, then we have lost, by their total destruction, what might well have been Donatello's greatest work.

Although the *Judith* was commissioned by the head of state, Cosimo de' Medici, and seems to have aroused general admiration, Donatello was ill at ease in Florence in the 1450s. For some unknown reason he decided to settle in Siena, itself a mark of anti-Florentine feeling. He worked there for four years, and there is documentary evidence for Vasari's statement that he completed the wax models for the doors of the Cathedral; but not a trace of them survives, and Vasari tells the horrifying story of how Donatello, in a fit of Florentine patriotism, destroyed the whole series.

On his return to Florence in 1461 Donatello undertook the last, and most liberated, of his great tragedies, the bronze pulpits in S. Lorenzo. They were commissioned by Cosimo, but we do not know where they were to be placed or how assembled.

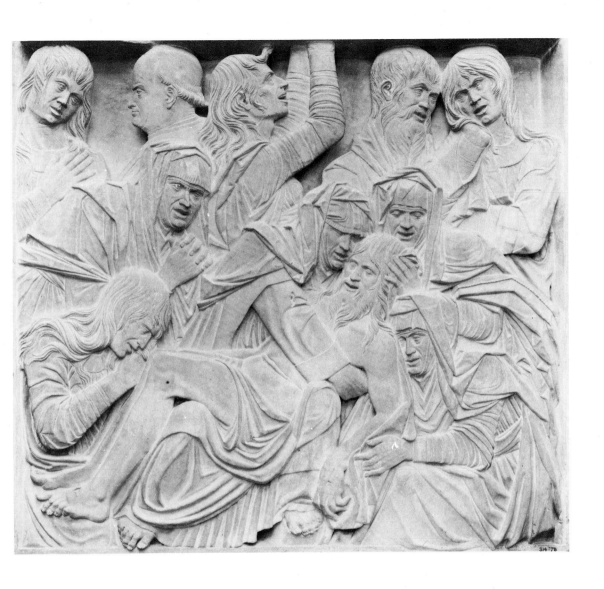

16 Donatello, *Lamentation over the Dead Christ*, c. 1455

The scenes of the S. Lorenzo pulpits leave us emotionally exhausted, as we are at the end of *King Lear* or the *Agamemnon* of Aeschylus. I might even say that to examine them in detail requires a certain amount of moral courage. The seriousness, the intensity, the unpredictable vehemence of each gesture, the total involvement of each of the actors in these extraordinary dramas, is so far beyond our ordinary apathetic lives, that we flinch from taking a part in them.

Both formally and iconographically the S. Lorenzo pulpits are of breathtaking originality. We find groups and attitudes that had never appeared in art before, handled with a rough, forceful freedom which looks almost like a conscious rejection of the smooth perfection of the Porta del Paradiso.

The most extraordinary sequence is on the second (the Epistle) pulpit, which starts with the descent into Limbo [17], reaches its climax in the Ascension and ends in a blessing of Rembrandtesque tenderness. In Limbo Christ is solicited with terrible vehemence by the Old Testament prophets, who feel that they deserve a better fate, even although they died before the Atonement, and He makes His way through their outstretched arms with serious steadiness of purpose. The next scene, the Ascension [18], is the strangest of all. Instead of a triumphant redeemer Christ rises from the tomb like a shipwrecked sailor who has narrowly escaped drowning. His grave clothes are still on Him, and even cover His head. Given the traditional message of the Resurrection, this is an almost incredible rejection of all precedents. The Ascension is also a departure from tradition, since Christ has not left the ground, and perhaps a better title would be the appearance of the Risen Christ to His Apostles. But at last the figure of Christ brings some comfort. Throughout, the force and freedom of Donatello's chisel in the draperies is astonishing, but some of the heads may have been finished by a less sensitive hand. In general the heads in the S. Lorenzo pulpits are the only part of them which leave me unsatisfied, and I do not think this is due solely to the intervention of an

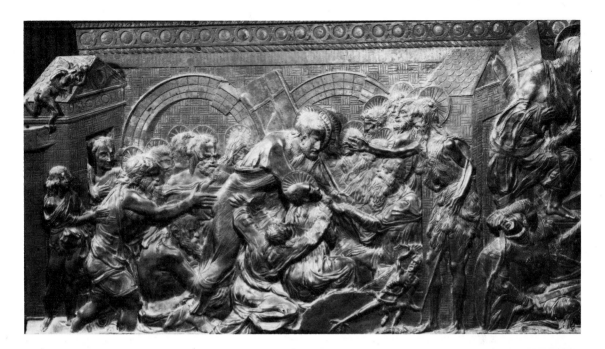

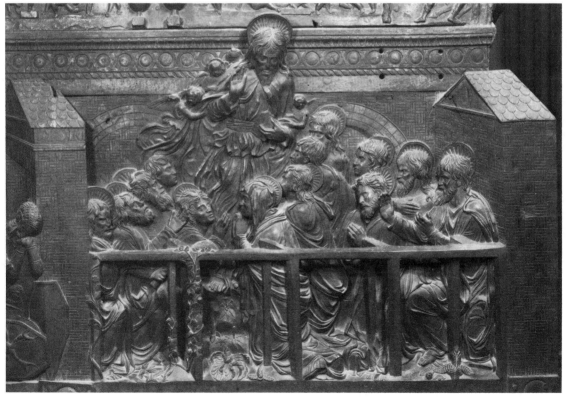

17 Donatello, *Descent into Limbo*, 1460–66
18 Donatello, *Ascension*, 1460–66

assistant. If one contrasts all these angry, monotonous, bearded old men
with the heads on the Santo relief—that marvellous cross-section of
human life—one feels that they may be an expression of Donatello's anti-
humanism, which first revealed itself in the Frari *St John*. Or was it
simply that he wanted to achieve by repetition some of the anonymous
power of a Greek chorus.

In the second half of the fifteenth century it would seem that
Donatello's sense of tragedy had no influence on Florentine art. The taste
for grace and sweetness continued in Botticelli and Filippino Lippi; the
enjoyment of pageantry in the paintings of Pesellino and in the charming
painted chests of the 1460s called *cassoni*. But strangely enough it had a
delayed action outside Florence in the two towns where he had lived and
worked, Padua and Siena. When Donatello was in Padua Mantegna
was a youth, Giovanni Bellini a boy. But they were both young men of
prodigious talent and no doubt they studied avidly the models and
drawings and small bronzes which Donatello was producing, and they
continued to draw inspiration from the Santo altar after he had left. In
Bellini's *Dead Christ raised from the Tomb* [19] the debt to Donatello is a
commonplace of art history. But no one, it seems to me, has recognised
how the *spirit* of Donatello runs right through Bellini's early work. In a
picture in the Brera of *The Dead Christ supported by the Virgin and St John*
[20] (one of the most deeply moving pictures of the *quattrocento*) we are
once more in the realm of the serious and the tragic. It is Donatellesque
not merely because of its subject, but on account of the touching human-
ity of the Virgin's head. For once she is represented as a middle-aged
woman who seems to interrogate her dead Son, as if He might still have
some message for her.

Donatello's influence persists up to the time of that turning point in
Bellini's life, the Pesaro altarpiece (say 1475) [21]. The saints are unques-
tionably inspired by the saints of the Santo altar. And in the Entomb-
ment, which was originally at the apex of the altarpiece, we have once

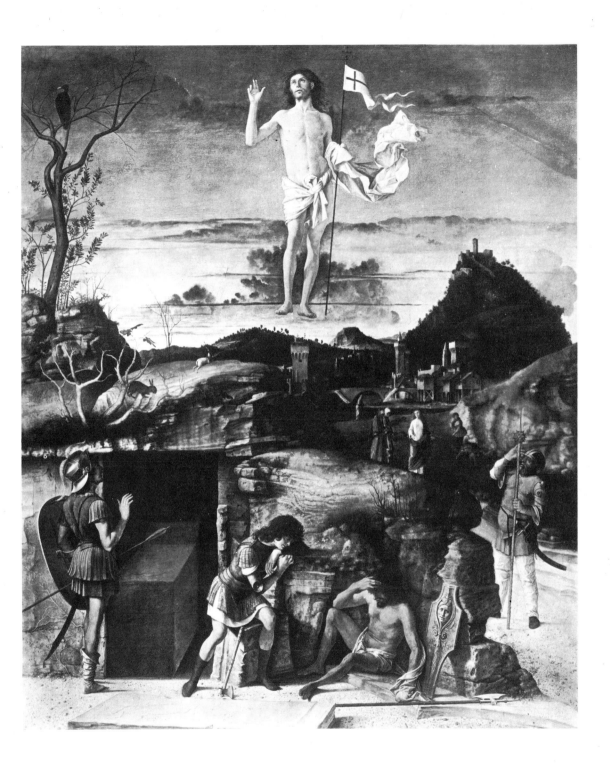

19 Giovanni Bellini, *Dead Christ raised from the Tomb*, late 1480s

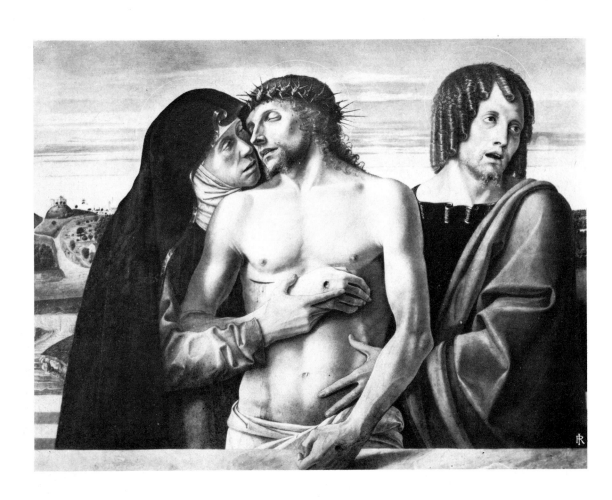

20 Giovanni Bellini, *Pieta*, c. 1468–71

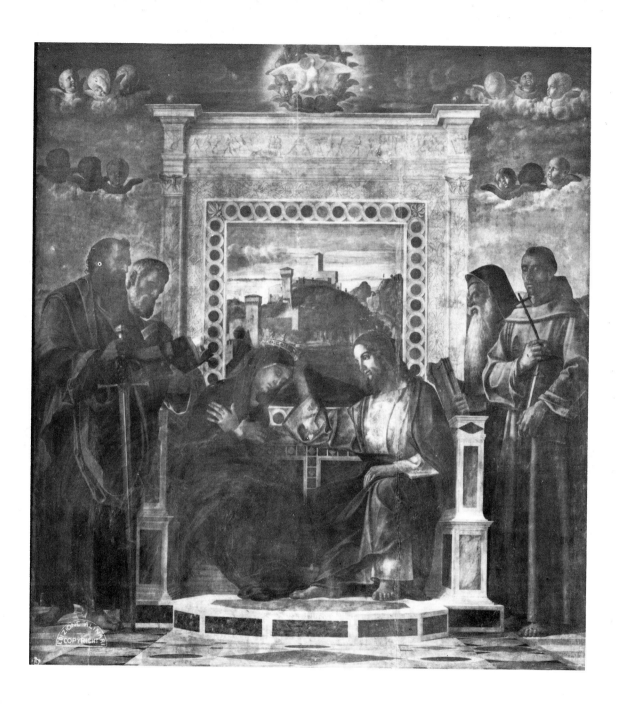

21 Giovanni Bellini, Pesaro altarpiece: *Coronation of the Virgin*, early 1470s

more the humanity and the tragic seriousness which was still out of fashion in Florence.

The debt of Mantegna and Bellini to Donatello is confirmed by their drawings. In their early work their drawing styles were so much alike as to provoke a controversy which is still unresolved. But it may be inferred that both of them followed the style of Donatello. Mantegna's drawing for the scene in the Eremitani of *St James led to execution* [Mantegna 4] reveals the same penmanship as one of the few probable Donatello drawings, a seated figure in Rotterdam; and the drawings that are related to it, whether by Mantegna or Bellini, and for the most part studies for engravings, are, I believe, a clear indication of the kind of drawings that Donatello did for the predella in the Santo. Later on each of them evolved his own drawing style, Mantegna's more classical, Bellini's more colouristic.

Thus, in the Veneto the serious view of human life that Donatello had maintained, with a growing sense of its tragedy, throughout his career, was still a source of inspiration ten years after Donatello's death.

The other delayed-action influence of Donatello's dramatic sense is in some respects more curious, and it involves an artist whose name is still relatively unknown, Francesco di Giorgio. He was twenty-one when Donatello left Siena in 1456, and was soon to make a reputation as a purveyor of charming Christmas card type pictures similar to those of his friend Neroccio. But when, in about 1475, he turned his most versatile mind to sculpture (he was also an admirable architect) and looked back at the Donatello models that must have been an inspiration to him in his youth, he became the closest and most intelligent follower of Donatello's later manner. An insignificant painter became a great sculptor. No wonder that it took a long time before art historians could accept as Francesco's work the beautiful reliefs that critics attributed recklessly to Pollaiuolo, Verrocchio, and even Leonardo da Vinci. A relief of the *Flagellation* [22] in Perugia unites the atmospheric background of

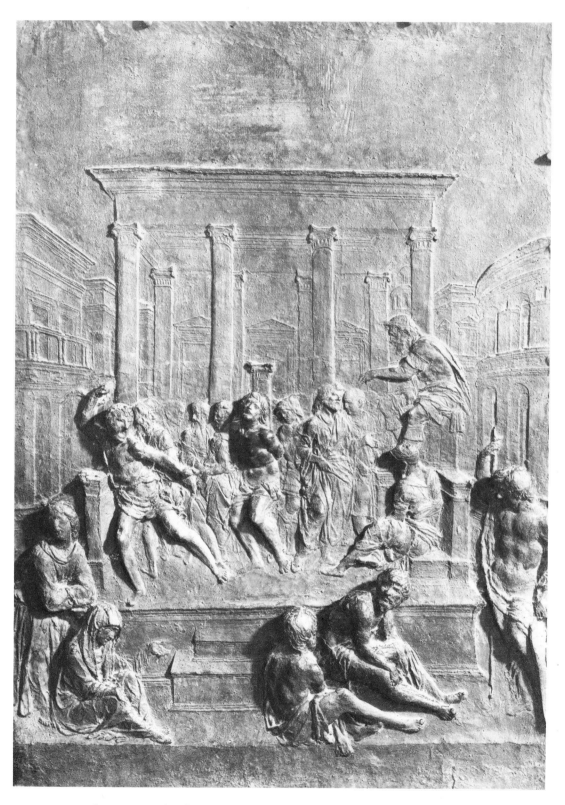

22 Francesco di Giorgio, *Flagellation*, late 1470s

Donatello's low relief with the large plastic units that seem almost to detach themselves from the scene, such as we find them in the S. Lorenzo pulpits. A relief in the Carmine, in Venice, executed for Federigo of Urbino, is a less astonishing performance because it lacks the atmos⁄pheric background of the *Flagellation*. But what an intensely moving work, more Gothic than Donatello, nearer to hysteria in the grief of the two central women, but still reflecting Donatello's grave humanity in the figures on the left. One cannot help marvelling at the inspiration that pervaded the Italian Renaissance when one finds how an artist who lived on the fringe of the movement could produce these masterpieces.

To take away Donatello from the *quattrocento* is rather like taking away Rembrandt from Dutch art. In Holland you would still have been left with Vermeer and de Hooch and Ruysdael. In Florence there would still be Fra Angelico, Luca della Robbia and Fra Filippo: not so bad. But historically the non⁄existence of Donatello would have been a disastrous loss. For one thing it would have left the early Giovanni Bellini little more than the continuator of Jacopo and it would have meant that an essential part of the Florentine spirit would have had no visible expression (except in the isolated Castagno) between Masaccio and Michelangelo, in fact for seventy years at a time when the Florentine intellect was burning most brightly. But perhaps such historical conjectures are futile. There are artists who belong to their age, and can hardly be considered outside their own special context—great artists even, like Botticelli and Delacroix. There are other artists who are for all time, who speak to us today as directly, and almost as intelligibly, as they did to their contemporaries: Giotto, Masaccio, Titian, Rembrandt—and Donatello. And if one asks why, I think one answer could be that their marvellous plastic or pictorial gifts were at the service of a deep feeling for humanity, of the pathos and of the almost inevitable tragedy of human life.[1]

[1] This essay is based on a lecture given at the Victoria and Albert Museum, 1976.

PAOLO UCCELLO AND ABSTRACT PAINTING

That the painting which grew up in the first two decades of this century was a revolution cannot be denied. But it was not quite as unprecedented as is sometimes supposed. I will try to show how the attempt to bring visual experiences into relationship with measureable shapes which is to be found in the work of Seurat, and passed on to painters of pure abstraction like Braque and Juan Gris, is first used consciously in the paintings of Paolo Uccello, where it embodies the doctrines of the leading art theorists of fifteenth-century Florence, Brunellesco and Alberti.

To critics of the last century this interpretation of Uccello would have seemed dreadfully perverse. They had placed him in their text books as one of the founders of a scientific approach to painting, and to them science meant naturalism. Up to a point they were right. In the early fifteenth century art and science were equally regarded as branches of knowledge, and knowledge of natural appearances was connected with the Aristotelian interest in natural science which was developing in northern Europe, and in such Italian centres of northern influence as Milan, Verona and Padua. But in Florence the type of knowledge sought was of a different order. It maintained that true knowledge must be more substantial and more precise. It must deal with essentials and certainties. Luca Pacioli, the leading mathematician of the late fifteenth century, who may appear as a sort of symbolic compère of this discussion, begins his book entitled *Of Divine Proportion* by a distinction between *Opinioni* and *Certezze*; and adds that the latter are established solely by mathema-

tics. Now Pacioli was the fellow citizen and pupil of Piero della Fran-
cesca, and one section of the *Divine Proportion* is derived from Piero's
unpublished work on the *Five regular bodies*, a work written as a result of
his studies of perspective[1]. So it is not surprising that to Pacioli perspec-
tive alone enabled painting to achieve these *certezze* which, as he be-
lieved, were the sole important realities. Thus he arrived at a notion of the
real, which has more to do with the realism of St Thomas than the
realism of Courbet.

Now, as I have just implied, this union of art and mathematics was
not unknown in the middle ages. The proportions of the great cathedrals
had a mathematical basis: among the mysteries of the masons there was
certainly a mystery of numbers. In the early thirteenth century Villard de
Honnecourt writes at the beginning of his sketch-book 'You will find
therein the art of drawing, the elements being such as the discipline of
geometry requires and teaches'. And although Villard's application is
rather crude, we can see that it is not merely a simplified trick of drawing,
but a real effort to discover the permanent, measurable shapes—the
certezze—which underlie the accidents of appearances. But the geometry
of Villard de Honnecourt [1] is very naïve and amateurish compared to
that of the Florentines of the early fifteenth century. I cannot tell you the
cause of this mathematical bias of the Florentine mind. But I can give you
two early symptoms of it, which in time became secondary causes. First of
all the geometric nature of architectural decoration in Tuscany during the
twelfth and early thirteenth centuries [2]. At a date when the rest of
Europe was drawing its decorative motives from organic life, the Tuscan
architects relied solely on abstract design. If a figure had to be included it
was reduced to the simplest geometrical forms, not from incompetence—
for the level of skill was at least as high as that of the naturalistic Gothic
craftsmen—but from a preference for geometric forms. I was brought up

[1] There are two copies of this manuscript, one in the Ambrosiana, Milan, in Latin, and
one in the Biblioteca Palatina, Parma, in Italian and written in Piero's own hand.

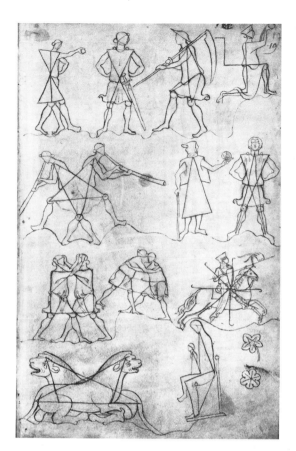

1 Villard de Honnecourt, Folio 19:
 Sketchbook, c. 1235

2 S. Miniato al Monte, Florence,
 detail of choir screen,
 12th century

on the myth that the discovery of geometry was due to Pythagoras's study
of the inlaid pavements of Egyptian temples. *Se non è vero* it is at least
probable that Brunellesco's mastery of geometry (and he was unquestion-
ably a great mathematician) was influenced by study of the marble inlays
of the twelfth-century buildings.

The other symptom is connected with that endowment on which the
material greatness of Florence depended: the unrivalled adroitness of the
Florentine bankers. All educated Florentines were brought up to use the
device known as the abacus, so that in the fifteenth century the Tuscan for
'he is being educated' was 'sta al abaco'—he is at the abacus. It is
extremely revealing that Piero della Francesca addresses his book on
mathematics to a business man who wishes to make the best use of the
abacus, and gradually leads him on to algebra and hence to the disin-
terested contemplation of the five regular bodies.

Such then was the predisposition of the Florentines towards a math-
ematical basis of design when Brunellesco discovered perspective. This,
of course, is a very crude statement of a complex problem. The ap-
pearance in the early fifteenth century of what for five hundred years was
accepted as 'correct' perspective, was primarily due to a change in the way
of seeing. The first representations of depth in Gothic art are rendered by
compartmental perspective, in which each section of the picture has its
own particular scheme, or by 'inverted perspective', in which receding
lines diverge instead of converging towards a vanishing point. This is a
method which seems to be in keeping with the linear, decorative, or
magic styles of painting, the styles of the East, and of gold backgrounds.
In Siena, for example, it is applied self-consciously up to the middle of
the fifteenth century. Giovanni di Paolo, for example, sometimes drew
architecture in diminishing perspective, and then corrected it to inverted
[3].

Now the change in the way of seeing to which I have referred took
place simultaneously in Flemish and in Italian art. There cannot, I think,

3 Giovanni di Paolo,
Birth of John the Baptist,
mid-15th century

be any question of cross influences. Lines converge towards a vanishing point in the miniatures of the Van Eycks [4] some five or ten years before they do so in the paintings of Masaccio; Brunellesco's demonstration of the same point of view was probably a few years earlier still. But given an initial similarity in the new sense of space, the applications of the principle were entirely different in north and south. In the north (except for Dürer, who is always a special case) perspective was originally, and remained until the seventeenth century, an empirical matter: the result of sensory perception—of what you saw if you looked through a window. It was guessed at, not calculated. Now this rule of thumb, empirical perspective was absolutely all that was required for naturalistic painting. If mere representation had been the aim of art, the labours of Brunellesco and Piero della Francesca would have been entirely superfluous—or, from their rigidity, actually misleading. But, of course, the perspective of the Van Eycks dealt with *opinioni*, not with *certezze*. It was Brunellesco who first propounded the theoretical and mathematical basis of the new way of seeing: that is why he may properly be said to have discovered perspective.

The importance of this discovery to the mathematically minded Florentines is obvious, and it was enhanced by the fact—and it does seem to be a fact—that the *theory* of perspective, as opposed to its empirical usage, was unknown in classical times. Although it was very soon connected with the theories of Euclid, Vitruvius and Plato, it was not contained or even hinted at, in their writings. This was perhaps the first time that the men of the Renaissance felt they had excelled that antique culture which both inspired and oppressed them. Although no autograph document bearing Brunellesco's calculations has survived, we have first-hand evidence of their nature. We have a long biography by someone who knew him and talked with him. And we have Leon Battista Alberti's book on painting, which is dedicated to him as to a most intimate friend and master. The means by which Brunellesco's

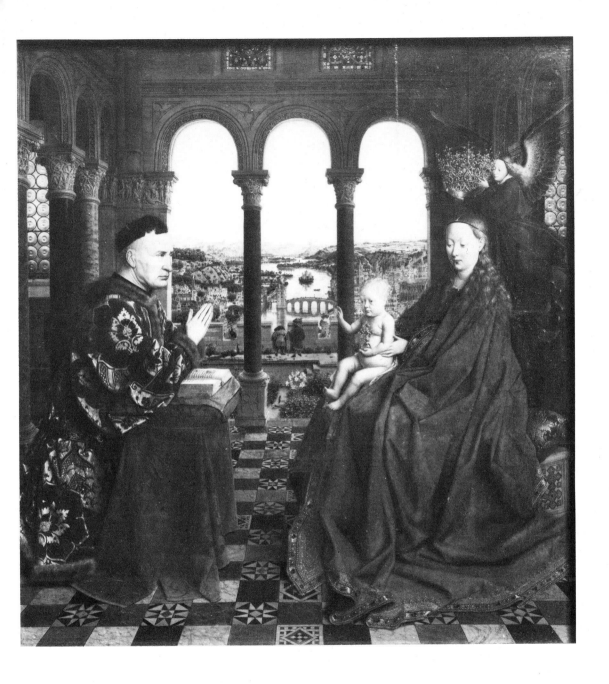

4 Jan van Eyck, *Madonna and Child with Chancellor Rolin*, 1435

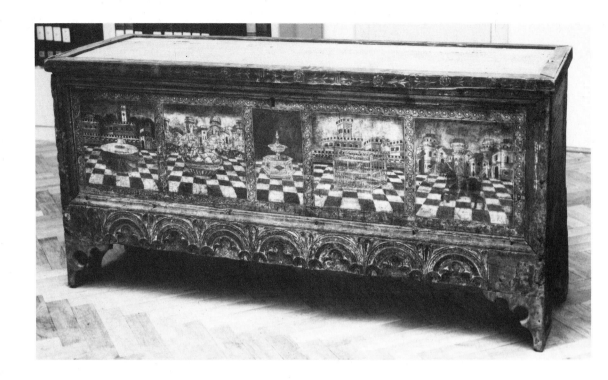

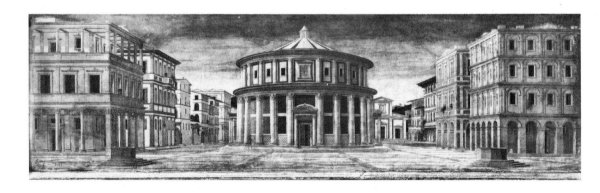

5 Milanese cassone with perspective views, *c.* 1490
6 After Piero della Francesca, *Perspective view of an Ideal City*, late 15th century

perspective scheme—the so-called *costruzione legittima*—was achieved are well known. But I would like to recall the demonstration in which he proved its effectiveness as it is described by his biographer (who for convenience I will call Manetti). It consisted of a painting on panel of the piazza of San Giovanni in which all the lines ran to a vanishing point and inlayed marbles were accurately diminished [5]. This painting is lost (although it survived the fiteenth century, and is mentioned in the Medici inventories), but we can gain some notion of what it was like from the architectural views which were painted for the palace of Urbino in the workshop of Piero della Francesca some fifty years later [6].

But Brunellesco's painting had two very revealing peculiarities. First, he was so determined that the point of view of the spectator should correspond exactly with the vanishing point that he made a hole about the size of a bean at this point, and made the spectator stand at the back of the picture and look through this hole at its reflection in a mirror—the distance of the mirror being adjusted to the supposed focal point from which the painting had been made. Well, there is *certezza* for you. But one problem remained insoluble—the sky. The sky was constantly changing; the clouds could not be said to occupy a given position in space—that Renaissance criterion of reality. So Brunellesco simply gave up the struggle and made the sky of his demonstration out of a piece of polished silver. Even without the sky we now realise that Brunellesco's perspective was not an accurate presentation of the facts of vision, for it left out of account the inevitable curvature of a flat plane parallel to the eye. Leonardo da Vinci seems to have been aware of this, and to have referred to it in his book on perspective. But the men of the Renaissance seem to have believed that perspective provided an accurate basis for naturalism.

Now for this reason it was possible to put into this framework relatively realistic figures, and such was the practice of the two artists who were most intimate with Brunellesco and influenced by him—Donatello and Masaccio. But it was inevitable that an ideal mathematical space

should invite artists to people it with equally ideal forms: forms, that is to say, which aspired to the condition of those regular, measurable bodies which could be constructed geometrically. This leads us on to a funda-mental belief of the Renaissance which floated half way between science and mysticism—thus maintaining the position of its originator, Pythagoras—the belief in harmonious proportion based on number. The importance of this conception in the early fifteenth century cannot be overstated. It appears in every branch of thought. Bruni even says in praise of Florence (1405) that the institutions of the city are in such perfect musical harmony with one another as to be aesthetically pleasing—surely one of the most quintessentially Florentine statements ever made. Now this belief in numerically established harmonies was not, as it might seem to us, a mere intellectual amusement. It was a very serious matter. Was not the whole universe kept in being by harmony? Did not Plato, in the *Timaeus*, teach that the creation of the world was a matter of geometry? Pacioli was using the epithet quite literally when he called his book 'Of *Divine* Proportion'.

From this book I illustrate two examples of what the term means. First a letter from Pacioli's alphabet [7] which is ideal because based on the two perfect forms, the square and the circle; the square establishing its general proportions, the circle, or a series of related circles, giving the serifs. Secondly, one of the engravings of regular bodies [8], actually derived from designs by Piero della Francesca in his *Cinque Corpi Regolari*. I will not go into the supposed mathematical importance of those constructions, but it is worth remembering the extent to which they influenced Renaissance principles of design. They even became favourite motives in the decorative arts and reach a wonderful perfection in wooden inlays known as *intarsie*, which are often found in *quattrocento* choir stalls. (They would be a rewarding subject of study, both for their subject matter and their design.) Although most of them are datable about 1500, or even later, elements of which they are composed were first used as a

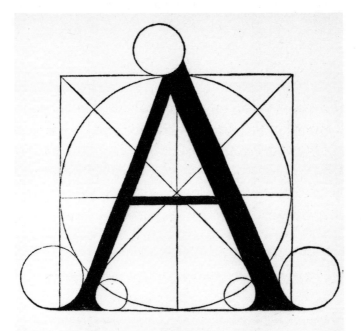

Quefta letera A fi caua del tondo e del fuo quadro:la gã
ba da man drita uol effer groffa dele noue parti luna de
lalteza La gamba feniftra uol effer la mita de la gãba grof
fa. La gamba de mezo uol effer la terza parte de la gamba
groffa La largheza de dita letera cadauna gamba per me
zo de la crofera. quella di mezo alquanto piu baffa com
me uedi qui pe li diametri fegnati.

7 Luca Pacioli, Letter A from *Divina proportione* . . . , 1509
8 Piero della Francesca, Regular body from *Cinque Corpi Regolari*, after 1490

basis of design fifty years earlier by Paolo Uccello.

We are so accustomed to associate perspective and pictorial science generally, with naturalistic representation, that it seemed worth taking some pains to explain how the most famous Florentine master of perspective should be the author of works which are certainly not convincing imitations of the visible world. They are not even convincing as renderings of space. In fact Uccello, in vision, belonged to the tradition of magic or decorative perspective. In spite of the diminishing lances of his battle pictures he did not naturally see the world as a single hollow box in which solid bodies were related to one another, but as a number of compartments, each one of which could exist separately. But to the working out of each compartment he brought a mathematical diligence which amounted to mania, and which, combined with his sense of decoration, gives his work its indestructible beauty.

Paolo Uccello was born in either 1396 or 1397 (he gave both dates), and we first hear of him in 1407, as workshop boy to Ghiberti, during the years when the first bronze doors were being designed. This is important, for it suggests both the Gothicism, which is inherent in Uccello, and the science. The first doors, of course, were designed before the emergence of Brunelleschian perspective, but they show in a high degree the application of geometry to composition which, as we can see in the notebook of Villard de Honnecourt, was part of Gothic tradition. Uccello's first recorded commission, dated 1424, was to work on the mosaics in St Mark's, Venice; that is to say he started as a decorator in a late Gothic style. When next we hear of him in 1435 he was one of the many artists engaged on designing the stained glass of the Cathedral of Florence. He was still, at the age of 40, a decorative artist.

We may take 1435 as the year in which Brunelleschian perspective ceased to be the mystery of a small circle, and had begun to influence the arts in general. It was the year of Alberti's book on painting, and of Ghiberti's perspective reliefs of the second doors. A year later Uccello

was commissioned to paint a memorial to the English condottiere, Sir John Hawkwood [9]. This is the first surviving example of perspective in his work, although it seems clear that others of the same date have been lost. It has been suggested that the painted socle is a later addition—by Uccello— but this does not affect the question, because fortunately the original drawing survives. The fresco has been frequently restored—the first time in 1524 by Lorenzo di Credi—and a comparison with the drawing [10] shows the extent to which it has been changed. This comparison also shows very clearly the true character of Uccello's art. An example is the horse's hindquarters. In the fresco there is an awkward attempt to give them the character of a war horse; in the drawing Uccello subordinates naturalism to the geometric beauty of this curve, which answers the curve of the neck. Similarly, the belly is part of a perfect arc. These rhythms were ignored by the various restorers of the fresco, who have attempted to give animation by the completely *un*-geometric swirl of the cloak. The importance of the circle in humanist aesthetics, that is to say in humanist symbolism, is well known. I have already referred to it in Pacioli's letters. Leon Battista Alberti's *De Re Aedificatoria* not only recommends it on account of its geometrical perfection and as a symbol of the Cosmos, but makes his usual appeal to nature, which in trees, nests, fruit and many other things shows his enjoyment of the round form.

There is, I think, no doubt that Uccello was greatly influenced by Alberti, and in particular by his *della Pittura*. This is particularly clear in the famous fresco of *The Deluge* [11]; he not only arranges his double vision of the Ark so that it is almost like the diagrammatic illustration of Alberti's first chapter, but he follows Alberti's advice in his treatment of the subject, introducing the profusion of persons and animals, the range of emotion expressed through gesture, and the fury of the elements, all of which the *della Pittura* recommends. In the 1440s, *The Deluge* must have seemed a miraculous work. Even today, when half obliterated by time, it makes a profound impression on those who have the good fortune to see it

9 Uccello, *Equestrian Monument to Sir John Hawkwood*, 1436

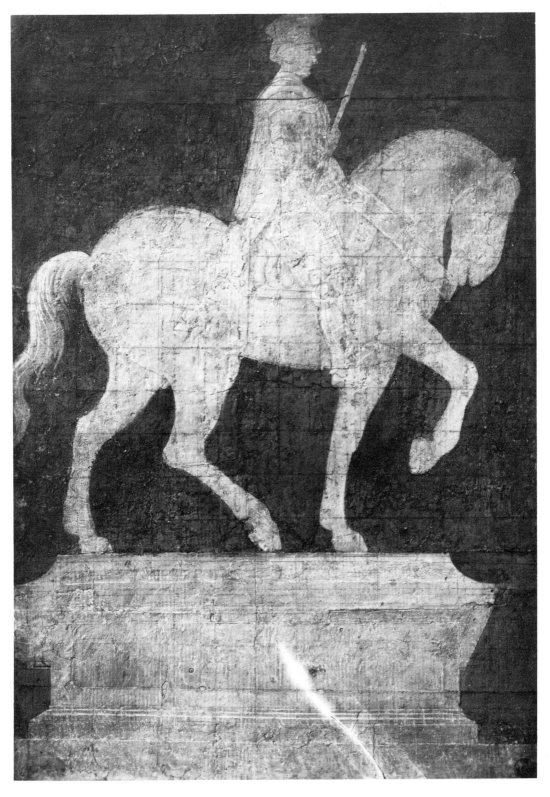

10 Uccello, *Study for the Hawkwood Monument, c. 1436*

in a good light. I may be forgiven for describing some of the incidents which are barely comprehensible in reproduction. The Ark is shown twice, on the left at the height of the storm, on the right when the floods have subsided and God is speaking to Noah. The figure of Noah, rising above the corpses of the drowned, is conceived with a Masacciesque dignity, and is the nearest Uccello comes to the true humanist style of Masaccio and Donatello. But in the left-hand side [12] he is really himself. The scene is lit by a flash of lightning which has struck the tree and set it on fire. All the figures, and even the ferns which, after long exposure to the waters, have grown on the side of the Ark, cast intensely black shadows and these effects of illumination are fleeting gestures of fear and desperation, as those of the figure crouching against the Ark. But all those dramatic impressions are combined with most durable conceptions of geometry. There is the floating ladder, with its diminishing transver-sals, the tub, providing Uccello with his favourite sphere, and, above all, that extraordinary object called a *mazzocchio* to which I shall shortly return. This desire to combine transience with permanence, lightning with geometry, might seem a personal fantasy of Uccello's were it not also characteristic of other great masters of mathematical painting. We see that Seurat's attempt to render the last seconds of sunset in terms of the golden section was something inherent in this whole attitude to art.

The accident of preservation which had made two *mazzocchios* the most prominent features of the *Deluge* has in it a kind of historic justice, for they are the symbol of Uccello's art, and were recognised as such even by Vasari. I should explain that they are really hats, and that the figure who is wearing his round his neck is doing so purely as a result of the emergency. They were polygons enclosing a sphere and were constructed of thin pieces of wood, covered with cloth, which occasionally was coloured to emphasise their structure. Their charm for Uccello obviously lay in the fact that they suggested how a continuum could be rendered as a series of planes. In the framework of a *mazzocchio* his favourite cylinder

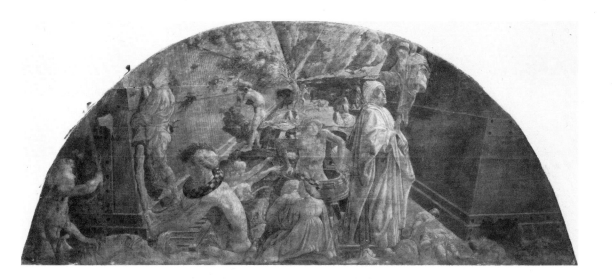

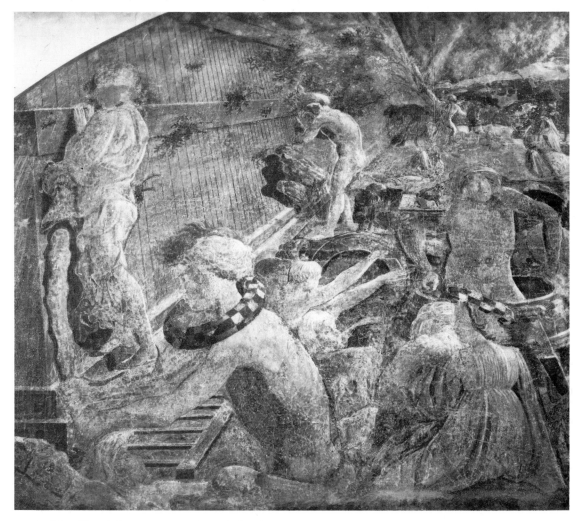

11,12 Uccello, *Deluge, c.* 1445–47, and detail

13 Uccello, *Drawing of a mazzochio*, c. 1430–40
14 Piero della Francesca, Drawing of a mazzochio from *De Prospettiva Pingendi* ..., before 1482
15 Daniele Barbaro, Drawing of a mazzochio from *La Practica della perspettiva* ..., 1568

was reducible to perspective. We know from Vasari that Uccello made many drawings of *mazzocchios* [13], three of which have survived, and you may see what a beautiful exercise in perspective they provide (it has, incidentally, been worked out by Kern in the *Prussian Jahrbuch* for 1915 and found to be correct). Actually a far more beautiful perspective drawing by Uccello is that of a cup. Vasari, who owned one of the *mazzocchio* drawings, tells us that Uccello left a whole chest full of such diagrammatic fantasies upon which more and more he came to spend his time. It is interesting to compare Uccello's *mazzocchio* with one drawn by Piero della Francesca [14]. There is also a drawing by Leonardo da Vinci in the Codice Atlantico of a similar construction, too solid for a *mazzocchio*, and closer to the regular bodies of Piero. It shows how the Renaissance mind was continually occupied with this problem of reducing the circle to perspective. They continued to provide a test of skill long after they had ceased to be fashionable as headgear: Botticelli is said to have done an excellent drawing of one, and they even survive into the mid sixteenth century in an illustration in the famous book of perspective by Daniele Barbaro [15].

Such are the elaborate, mathematical constructions which underly the violence of Uccello's *Deluge*, and we may even say that geometry heightens the drama. This is the first example of an aesthetic discovery, of which ample use was made in later centuries, that a steep perspective in some way intensifies our feelings. The common phrase, 'violent foreshortening', is evidence that we are all unconsciously aware of this effect. Perhaps it is partly connected with our feelings of giddiness in looking down from a height, and there is also the nightmare tunnel with all its psychological implications. But even the extreme foreshortening of a single figure produces a heightened emotion, as is proved by Mantegna's dead Christ in the Brera. It is as if our senses, used to operating on a given pattern of recognition, are suddenly asked to take in a complex of forms at far greater speed, and so raise the tension of our whole being. It would be interesting

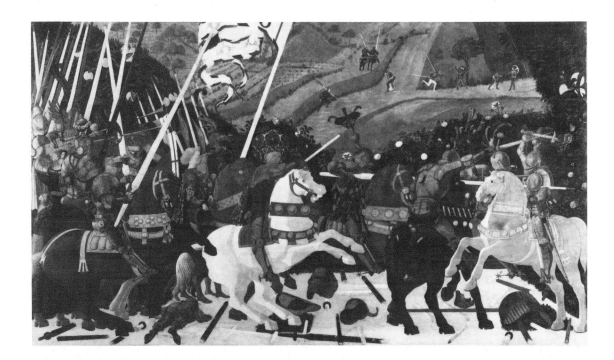

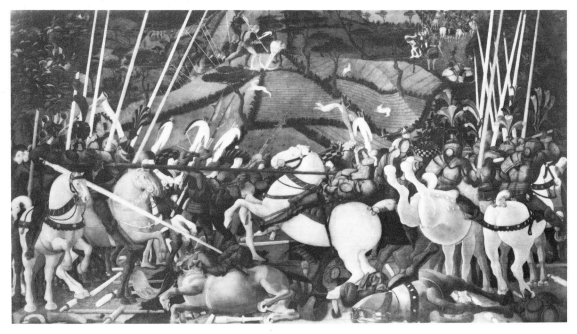

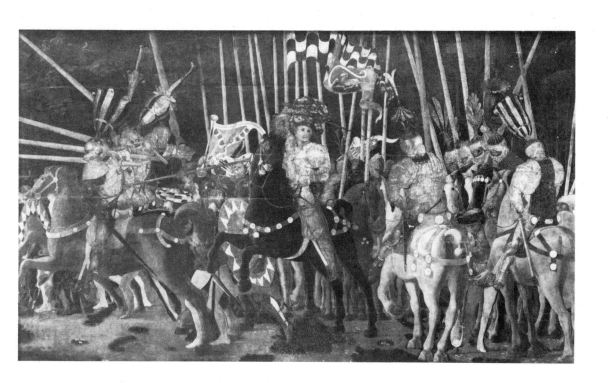

16–18 Uccello, *Rout of San Romano*, c. 1450

19 Florentine engraving, *Wild animals attacking horses and oxen. c.* 1460

to know if Uccello was conscious of this effect, and employed it in other works now lost. The fragmentary frescoes at S. Miniato suggest that he did not, for in them the perspective scheme is entirely detached from the figures, which are the reverse of dramatic. And I am inclined to think that the drama of the *Deluge* composition was inspired by that great master of *terribilita*, Donatello, whom Uccello visited in Padua, immediately before the paintings in the Chiostro Verde, when Donatello was working on the Santo altar. Certainly the only comparable use of dramatic space is in one of Donatello's reliefs for the altar in which St Anthony heals the leg of the bad-tempered son.

The fresco of the *Deluge* seems to have been painted about 1446. The battle pieces, which are the only major works of Uccello to have survived in such condition as to give us an idea of his original intentions, are at least ten years later. They were painted for the Medici Palace in the Via Larga, which was being furnished in the 1450s, and we know from the Medici inventories that they were originally arranged in one frame, with the National Gallery picture on the left, the Uffizi in the centre, and the Louvre on the right [16, 17, 18]. The room contained two other paintings by Uccello, representing a battle of lions and horses, and lion fighting a snake, which seemed to Vasari far more admirable than the battles; but these, both on canvas, were already recorded as torn in the inventory of 1598 and have disappeared. Perhaps we can learn something about them from a Florentine engraving in which the foreshortened horses point unmistakably to an Uccellesque origin [19]. A sixth picture of the series, representing a hunt, was by Francesco Pesellino. Pesellino died in 1456, and if the decoration of the room was conceived as a whole (which is by no means certain) Uccello's battles must antidate that year.

The description of the lost canvasses tells us one important thing about the battle pictures — that the whole scheme was though of in the chivalric, decorative convention of late Gothic. The pictures, as so often, were no more than a cheap substitute for tapestry, and would be expected to make

a similar effect. This explains to some extent the striking fact that they are
so much less concerned with the problems of depth than the frescoes of ten
years earlier. But it is not the whole explanation. Uccello was by training
a decorative artist. He had spent six years working in mosaic; for about
ten years, he was chiefly at work on the stained glass windows of the
Florentine Duomo. These were forms of art in which naturalism and the
representation of depth were excluded, and we can understand how, by
1456, Uccello had come to think of shapes and colours almost entirely as
vehicles for his sense of pattern. Not that the Battles are entirely devoid of
dramatic interest, although to some extent it is concealed by heraldry, as
well as by dirty varnish, and we have to look for it in the details [20, 21,
22]. The foreshortened head, lit by light reflected from the white horse's
flank (here, [18] incidentally, you see a *mazzocchio* being worn correctly)
is a link between Masaccio and Pollaiuolo, and still in accordance with
the ideals of Alberti.

These details show that Uccello was far from being the Noah's Ark
and rocking-horse painter which the superficial have supposed him to be.
The National Gallery panel greatly exaggerates the rocking-horse ele-
ment because it has been over-cleaned. The sharp division of planes on
the horse's flanks is underpainting intended to be modelled over with
small strokes. The Louvre panel, which has recently been cleaned by a
gentler hand, gives more of Uccello's intention, and, although far from its
original brilliance, is on the whole the best preserved of the three. The
Uffizi panel is abominably dirty, and best seen in photographs.

But, granted that the details are more vivacious than is supposed, the
general effect of the battles, unlike that of the *Deluge*, is undramatic. They
are completely lacking in movement. The very fact that they are so closely
designed, that every part of the picture justifies its own existence and
arrests the eye with satisfaction, leads to immobility. This used to be made
a criticism of Uccello, but we can see from his other works that in this
instance he was not aiming at drama.

20 Uccello, *Rout of San Romano* (detail)

21 Uccello, *Rout of San Romano* (detail)

22 Uccello, *Rout of San Romano* (detail)

Can we then say that he was aiming at decoration? Only if we give the word a more intellectual and less purely sensuous meaning than is usually accorded it. For the inexhaustible interest and beauty of his patterns is undoubtedly due to their being based on very elaborate geometrical calculations. In the battle pieces his perspective is not to be sought in the naïvely receding lances on the ground, but in that extended use of the term which, as I said earlier, includes the harmony of shapes, the five regular bodies, and other Pythagorean conceptions which, by analogy, were included under the term *prospettiva*. Take, for example, his treatment of the circle, and its derivatives, the arc, the sphere and the cylinder. Any fragment of the battles will show the incredible ingenuity with which Uccello sought for, and arranged this 'perfect' form, taking every advantage of armour and trappings, and even creating such improbable spheres as the enormous oranges in the background of the National Gallery picture, or the knotted tail of a horse. These circles are modulated in trappings and the mouths of trumpets, and are extended in the arcs of horses' quarters, necks and harness.

In his attempt to reconstruct the visible world in measurable symbols, Uccello follows much the same procedure as the Cubists—though with much greater science—and arrives at the same unexpected result: decoration. Like other scientists of the Renaissance, he went out in search of *certezze mathematici*, and soon found himself engrossed with *ludi mathematici*. Mathematics, which appears to be the most practical form of human activity, rapidly becomes the most completely self-consistent or, as we say, the *purest* of intellectual pursuits. And so it is not surprising that Uccello achieved a synthesis of his Gothic fantasy and Euclidean logic: a synthesis so complete that we can never be certain whether a happy passage of design is a triumph of taste or of calculation.

As the first enthusiasm for Brunelleschian perspective—or perhaps we should say Albertian theory—died down, Uccello's natural Gothicism reasserted itself. The 1450s and '60s in Florence saw a revival of Gothic

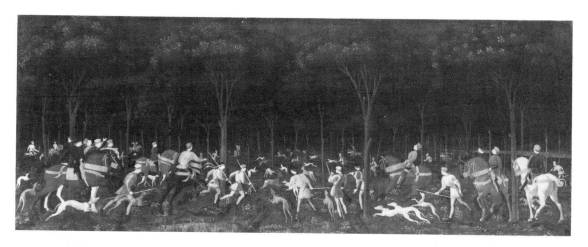

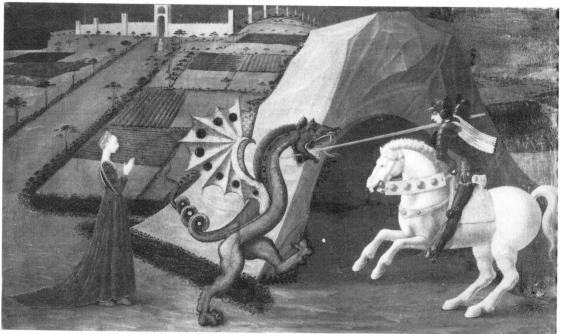

23 Uccello, *A Hunt in a Forest*, 1460. Ashmolean Museum, Oxford
24 Uccello, *St George and the Dragon*, 1456–60. Musée Jaquemart-André, Paris

taste. Flemish painting and, still more, Franco-Flemish tapestries became an important influence. Uccello's decorations in the Medici Palace were already in the manner of hunting tapestries. His only other well preserved work, the *Hunt in a Forest* [23], must be of about the same date, and is also in the Burgundian taste. The wood is as dark as night—a fashion of the '60s, as we see from the Madonnas of Fra Filippo—and the trees fill the whole background as they do in the illuminations to Gothic hunting manuscripts. This enchanting picture can never have been more than a minor part of Uccello's output—probably no more than the side of a large chest—and before it we realise more than ever what we have lost by the almost total destruction of his work. The design of the parts is once more of extreme beauty, but although the eye dwells with complete satisfaction on such a group as the horsemen on the left, in this picture the completeness of each pattern does not prevent movement. Uccello has used a more fluid kind of Gothic shape, and has combined the bounding rhythms of the dogs with the diagonals of the staves. As a result this picture is full of vitality. The figures themselves have the spring and elegance of the athletes and satyrs on a Greek vase. The *Hunt* is also one of the few works since the *Deluge* in which Uccello applies his perspective in the modern sense of the term. The diminution of the tree trunks and the hounds is subtly contrived to lead the eye back into the distance, and the whole is contained within a single space.

With the predella of a lost picture painted for the confraternity of Corpus Domini in Urbino between the years of 1465 and 1468 we are back at compartmental vision at its most fantastic, and we see how fundamentally Uccello sympathised with the inverted perspectives of the Gothic linearists. Unfortunately the surviving panels are entirely over-painted, so that only the composition and, to some extent, the silhouettes can be referred to Uccello; but at least they show the way in which he has varied the perspective scheme in two adjacent interiors, with strangely exciting results. No doubt the sharper perspective of the right hand

compartment was due to his desire to show the soldiers on the outside of
the door as well as the frightened family inside. But the result has been
greatly to increase the tempo of the scene, and to express, as in the *Deluge*,
a feeling of tension and terror.

In some of his late works, however, he seems to have given up re-
cessional perspective altogether. This is certainly the case in the picture of
St George and the Dragon [24], in the Jacquemart André Collection,
which, on balance, I am inclined to believe is by Uccello himself, and
not by his pupil, Giovanni di Francesco. The very extremity of abstrac-
tion is such as no follower could have attained. Although looking at first
sight like a nursery picture, any student of design can recognise that the
relation between these curves is extremely subtle and complex—the
assonance between the shape of the rock and the Princess is an example.
But we are bound to admit that Uccello's pursuits have led him into the
kind of art which easily degenerates into picture-making.

In relating these aspects of Uccello to the problems of modern painting
we may begin by a comparison with Seurat, a painter whose interest in
scientific problems for their own sakes gives him a remarkable affinity
with Uccello. Seurat himself was aware of this. His first great picture, the
Baignade [25], was influenced by Piero della Francesca, copies of whose
frescoes he had seen in the École des Beaux-Arts. But for his second, the
Après-Midi à la Grande Jatte [26], there is no doubt that he turned for
inspiration to Uccello's battle pieces, that in the Louvre being perfectly
familiar to him. You see that his obsession with science has given him the
same mania for shapes. As with Uccello, the fundamental shapes are
geometric, but both artists developed an increasing interest in shapes
which are apparently irrational, or in which the modulus is very greatly
reduced: for example, the gentleman's cane, hand and cigar, which are
extraordinarily like the thumbs on Uccello's crossbows. In the present-
ation of these shapes both Uccello and Seurat show great ingenuity in
providing a setting for a silhouette. But here Uccello has a very great

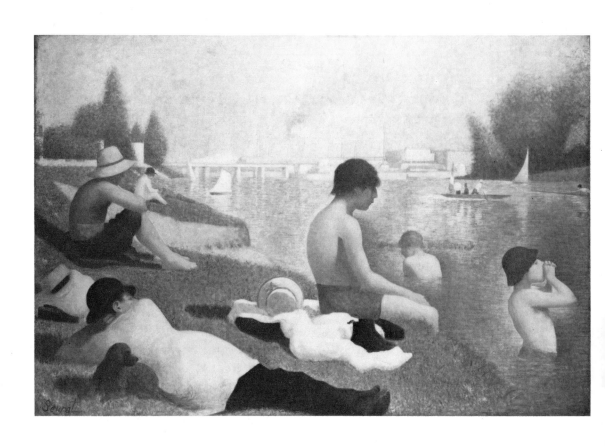

25 Seurat, *Baignade*, 1883–84

advantage. Since he takes his departure from the conventions of medieval art and the technique of mosaic he feels perfectly free to change the ground in an arbitrary manner. Thus, in the National Gallery picture, the earth is pink, but in order to emphasise the shape of this horse's hooves, Uccello has set them on a little hearth-rug of dark grass. Seurat, on the other hand, still takes his point of departure from impressionism, and so has to show some kind of naturalistic justification for all his patterns; and in order to emphasise his shapes, he has had to contrive pools of light and shadow. In his landscapes based on sensation he has done so with very beautiful effect. But when he came to figure subjects the difficulty of combining strict geometrical design with his inheritance of impressionist vision becomes disturbingly apparent. In *Grande Jatte*, for example, the silhouetted heads are still *impressions*, simplified by an accident of lighting. Seurat could not give forms reality by creating them from knowledge. Uccello, on the other hand, could use his knowledge and his laws of construction to work into his design phenomena which he could not have seen: for example, in the Louvre battle-piece he makes a close-wrought pattern out of the upturned hooves of galloping horses, complete with horseshoes—something entirely outside the range of impressionist perception.

The Cubists, who thought that they had renounced the data of sense perception, still took their point of departure from the Impressionists. For example, they made their constructions out of 'still life', things which could have been seen and arranged in some such connotation which clearly recalls the sort of designs which Uccello threw in gratis in the corner of his compositions. The fact was that a century of naturalism, culminating in impressionism, had so much influenced the popular conception of what a picture should be like that it had become almost impossible to conceive of one in which the design was paramount and the visual impression secondary. The abstract pictures of 1912 by Braque and Picasso changed the situation but did not entirely transform it. Their

construction was still made out of still life, which was based on an arrangement of visible objects, whereas Uccello, who was not limited by visual experience, could throw in admirable pieces of landscape in the corners of his pictures, where they took their place in relation to the whole.

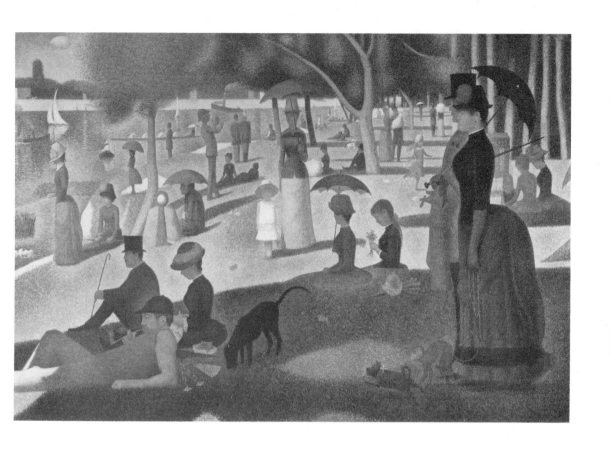

26 Seurat, *Sunday Afternoon on the Island of la Grande Jatte*, 1884–86. (Courtesy of the
Art Institute of Chicago)

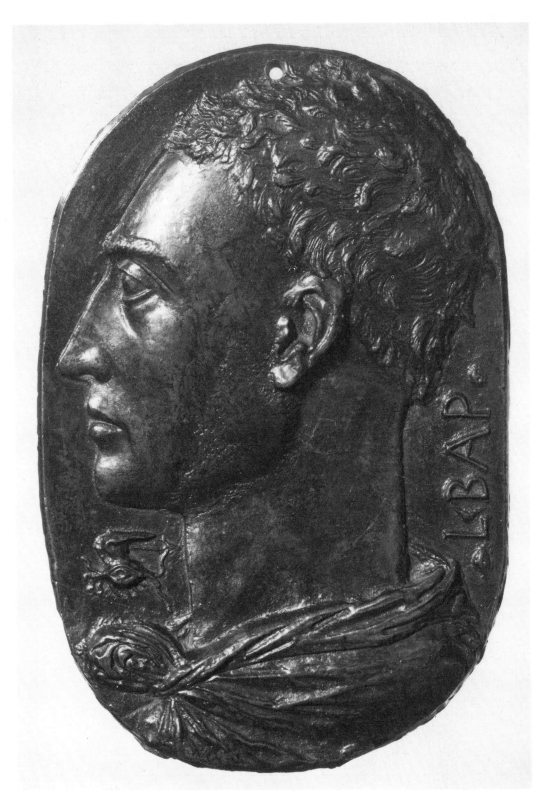

1 Leon Battista Alberti, *Self-Portrait Plaque*, *c.* 1435

3

LEON BATTISTA ALBERTI

ON PAINTING

At 8.45 on the 26th of August 1435, Leon Battista Alberti completed the
first treatise on the art of painting ever written,[1] and dedicated it to his
friend Brunellesco with these words:

When I compared the arts and letters of the ancients with those of modern times, I
thought that nature, mistress of those arts, had grown old and worn out, and no longer
produced the mighty and well contrived works with which, in her glorious youth, she
had been so lavish. But since I have returned to this country of ours from the long
exile, in which we Albertis have grown old, I have perceived in many—first in thee,
Filippo, and then in our dear friend Donato, and in those others, Nencio, Luca and
Masaccio, a talent for all praiseworthy arts which the most famous of ancient cities did
not excel.

Alberti, as he says, had only recently returned to Florence. He was the
illegitimate son of a patrician family which had acquired great riches by
the wool trade in the fourteenth century, but had been driven into exile by
the persecution of the Albizzi. Leon Battista was born in Genoa in 1404,
and educated in Padua. As a boy he was a profound student of the
classics, and even wrote a Latin comedy which was taken for an original
production of antiquity. He refused to go into the family business, and to
support himself he was forced to study law in Bologna; but overwork

[1] This treatise, usually referred to as *della Pittura*, was probably written in Latin and
translated into Italian by Alberti himself. The date 26 August 1435 is to be found on a
manuscript text in Latin, probably holograph, in the Marciana; the only Italian text, now in
the Bibl. Nat., Florence, is dated 17 July 1436. This was first printed by Bonucci, *Opere
Volgari di L. B. A.,* Firenze, vol. iv, 1847. Bonucci's text is divided arbitrarily into chapters
and has numerous misreadings; and the best modern edition is by H. Janitschek, *L. B. A.'s
kleinere kunsttheoretische Schriften*, Wien, 1877. The references to the *della Pittura* in this essay are
to Janitschek's edition.

brought on a serious illness, and he turned for relief to mathematics, music, and physical exercises, in all of which he attained a fabulous proficiency. He was also intimate with Filelfo and other masters of the new learning, and when, in 1426, the ban of exile on his family was lifted and he was free to return to Florence, he must have entered immediately into the circle of humanists, Poggio, Niccolò Niccoli, and the rest, whose friendship he gained not only by his knowledge of ancient literature but by the grace, intelligence, and the antique dignity of his conversation. By the humanists he was evidently introduced to the artists who were interpreting their ideals of human life; for although he was forced to leave Florence almost immediately and spend the next five years in travel, he could, soon after his return, refer to those artists as old friends.

In 1432 he became a member of the Papal civil service and settled in Rome; and there, in that half-abandoned city, where the ruins of ancient grandeur towered above the miserable huts and tenements of the Middle Ages, he began to study the art and architecture of antiquity. We may assume that in his researches he was often accompanied by Donatello, who was in Rome from 1431 to 1433 working on the Tabernacle of the Sacrament in St Peter's; and no one else then living was better qualified to open his eyes to the large rhythms, the calculated harmonies and the full humanity of classical art. At the same time the scientific and realistic bent of his mind led him in another direction, and in these years he construc-ted, perhaps invented, a *camera obscura*. We are inclined to underrate the importance of a device which has since become common knowledge, but of all Alberti's achievements this perhaps was the one which most impressed his contemporaries, even Vasari, who for many reasons was hostile to him, compared it to the invention of printing. Alberti refers to it several times in his writings, and in an anonymous biography[1] of which,

[1] First printed in Muratori, *Rerum Italicarum Scriptores*, vol. xxv; reprinted in Bonucci, *Op. Volg.*, vol. i, p. xc. Although written in the third person it contains intimate details which have all the character of self-revelation.

I suspect, he himself was the author, he says:

He also wrote several books on painting and in that art achieved unheard of, and to his spectators, incredible results. By looking into a box through a little hole one might see great plains and an immense expanse of sea spread out till the eye lost itself in the distance. Learned and unlearned agreed that these images were not like painted things, but like nature herself. These demonstrations, as he called them, took place by night and day. In the former you saw Orion, Arcturus, the Pleiades and other shining stars, and the moon rising above high mountains; by day you saw the blaze of dawn as Homer describes it. Certain Greeks, famous men and skilled seafarers, were astonished when he showed them, in his little world, a ship far out at sea. 'Now it labours in the tempest,' he said, 'but tomorrow you will find it in harbour.'

Making all allowances for exaggeration, for even the austere Alberti sometimes indulged in the national weakness, this seems to have been a remarkable invention, preceding the *camera obscura* of della Porta by over a hundred years. But for our present purpose its interest lies in the fact that Alberti thought it had a direct bearing on the art of painting, and when referring to it in his treatise on the subject, calls its images *miracoli della pittura*. And so already in these Roman years we find that dual approach to painting, the stylistic and the scientific, which was characteristic of Florentine art and of which Alberti was the first interpreter.

To this date also belongs the work by which, in his lifetime, he was best known, his treatise on the Family;[1] and although this is not the place in which to consider Alberti as a moralist, a word must be said about his ethics, since they help to indicate the moral climate of Masaccio and Donatello. He might be described as a Protestant humanist. He believed with passion in the greatness of man and the supremacy of human values; but the traditions of his hard-headed, hard-working Tuscan family gave to his humanism an austerity and a belief in the sanctity of work which

[1] The first three books were written in 1434, and later revised; a fourth book, more interesting, was completed in 1441 and the whole published in 1443. But in spite of its great contemporary renown it fell into obscurity and was not printed till 1844, Bonucci's *Op. Volg.*, vol. ii.

even Cicero would have reckoned a little severe. He upheld, and by his own life exemplified, the triumph of the human will; and his relentless self-discipline resulted in a lack of certain qualities which we value to-day—humour, for example, and sensibility. We cannot turn to Alberti's moral writings for relaxation. Carlyle, had he known them, would have made the author one of his heroes, although he would have had to suppress (as he did with some other heroes) the bitterness and the complete lack of religious feeling which characterise many of Alberti's reflections. We must admit, however, that Alberti's *gravitas* was relieved by *pietas* and *humanitas*, a genuine feeling for family life and for the fundamental affections on which a healthy society depends; and to judge by those who sought his company he must have been more human and more adaptable than his writing would lead us to suppose.

In addition to his natural sympathy with the Florentine ethos Alberti brought to his study of art certain special qualifications. He had noted every allusion to the subject in Plato, Aristotle, Plutarch, Lucian, Quintilian and above all in Pliny. But although Alberti is proud of his classical learning he recognises the shallow and fragmentary character of ancient art criticism, and places more stress on first-hand experience. 'He would learn from all,' the anonymous biography tells us, 'questioning smiths, builders, shipwrights and even shoemakers lest any might have some uncommon or secret knowledge of his craft; and often he would feign ignorance in order to discover the excellencies of others.' Moreover he had practised art himself, and speaks of his skill with unusual complacency in the *della Pittura* and other writings.[1] He refers particularly to his modelling in wax and his portraiture; and the only surviving work of

[1] *della Pittura*, ed. Janitschek, pp. 97 and 121; cf. also *Tranquillità dell' Animo* in *Op. Volg.*, i, p. 26, and his letter to Leonello d'Este prefacing *de Equo Animate*. The anonymous biography twice mentions him as an artist (*Op. Volg.*, i, pp. xci, ciii). Important outside testimony of his skill is that of his friend Cristoforo Landini, who mentions that several of his works were in the Rucellai collection. Vasari (ed. Milanesi, vol. ii, p. 546) claimed to own some of his drawings but had a poor opinion of his skill.

art which can with probability be attributed to him, justifies his pride. This is the superb bronze plaque of his own head in profile [1], which fixes Alberti's character in our minds more vividly than all his dialogues and recorded sayings.[1] It shows an almost Miltonic mixture of pride, sensibility and disillusion, and explains why his works contain, in equal proportions, panegyrics on Man and savage satires on the human race.

Such was the formidable young man who, in the summer of 1434, returned to Florence and resumed his friendship with the circle of humanist artists. After less than a year spent in studying their works and listening to their conversation he was prepared to give theoretical shape to what he had learnt. The result was the *della Pittura*, dedicated, as we have seen, to Brunellesco, Donatello, Ghiberti, Luca della Robbia, and Masaccio. Why did he choose these artists? Why, in particular, was a book on painting dedicated to an architect and three sculptors—the only painter named having died before Alberti's first visit to Florence?[2] For answer we must try to define the character of the artistic revolution which had taken place in Florence during the last fifteen years.

In 1401 Brunellesco and Ghiberti, competing for the bronze doors of the Baptistry, submitted as their trial pieces the first self-consciously humanist works of the Renaissance [Donatello 1, 2]. But this was like the abortive rising which precedes a revolution, and for another twenty years the old traditional styles went on unmodified. Of these the most popular

[1] Formerly in the Dreyfus Collection. There is an inferior version, possibly also by Alberti, in the Louvre. The authorship of the plaque has been much disputed. The old attribution to Pisanello is out of the question from every point of view. The relief is too pictorial for Ghiberti and too lacking in plastic sense for Donatello. In fact it is not in the style of a professional sculptor, and curiously enough the artist whose work it most resembles is Francesco di Giorgio, although, of course, preceding his Carmine relief by some thirty-five years. This portrait must date from about 1435. The medal of Alberti by Matteo de' Pasti dating from 1450 shows him graver, heavier, more Roman; but we cannot téll whether this is due to sitter or artist.

[2] Janitschek's suggestion that the Masaccio referred to is also a sculptor, the obscure Maso di Bartolommeo, is a piece of Germanic pedantry which need not be taken seriously.

was a faint echo of the Giottesque. In Giotto's own lifetime his solid, heroic figures had been turned by his followers into decorative symbols, and after a hundred years of repetition these had become shapeless, lifeless, and insignificant. In wayside shrines and country churches they satisfied the natural conservatism of the devout, and the family workshops in which they were manufactured—the Gerini and the Bicci—continued to flourish until the middle of the *quattrocento*. But by 1420 this old-fashioned Tuscan style no longer pleased the fastidious. Aristocrats and higher clergy, men who had travelled and visited courts, preferred the elegant new Gothic style which had been invented in Burgundy and imported into Italy through Verona. It was essentially a courtly style in which everyone was gentle and well dressed, with plenty of leisure to enjoy the beauty of flowers, birds, and brocades. And in 1423 it achieved in Florence a masterpiece which delighted, and has never ceased to delight, all lovers of pretty things, Gentile da Fabriano's *Adoration of the Magi*. But the hard-headed Florentine bourgeoisie could not be at ease for long in this exquisite society. As they grew in power and independence they felt the need of a world like their own, a world of common sense and serious human values, of forthright criticism and intellectual mastery, where all knowledge, both ancient and modern, was concentrated for the use of man; and by about 1425 a new style is fully apparent. In that year Brunellesco's façade of the Innocenti is almost complete, and Ghiberti, abandoning at last the Gothic style which was congenial to him, has begun to work on the second doors of the Baptistry [Donatello 3]. In that year Masaccio has executed what seems to have been the first great humanist painting, his fresco of the Consecration, now destroyed, and Donatello, in his relief of the Feast of Herod in the Baptistry at Siena [Donatello 6], has revealed his Shakespearian grasp of human drama.

When therefore Alberti returned to Florence in the train of Eugenius IV this style had been established for almost ten years. Brunellesco's transformation of the old Tuscan manner by mathematical lucidity had

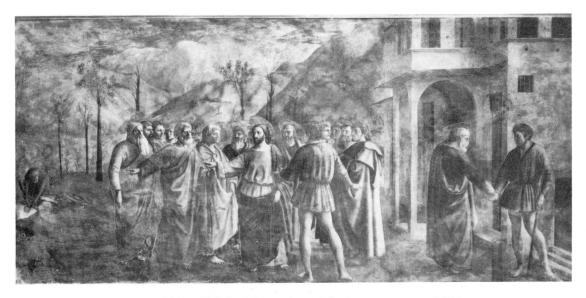

2 Masaccio, *Tribute Money*, 1425 3 Masaccio, *St Peter distributing Alms* (detail), 1425

become the accepted Florentine building style. Masaccio had painted his masterpieces in the Carmine chapel [2, 3] and died; Ghiberti had realised in his reliefs the new principles of space composition; Donatello had developed a sort of sculptured picture-making which gained intensity by the very recklessness with which the limitations of the medium were defied. And a new sculptor had emerged, Luca della Robbia, whose name sounds rather strangely in Alberti's list of great artists, until we remember that at this time he was only known by one work, the Cantoria of the Duomo (1431) [4], which must have seemed to promise an unrivalled skill in combining clear architectural forms with easy naturalism.

What then are the principles which the work of these artists reveals? First, their subject is human beings, grave and passionate, whole-hearted and intelligent; and these human beings are so placed in the composition as to appear to be in correct and harmonious relationship to one another. In order to achieve this effect the artist must be master of pictorial science, the word science being used in the narrow sense which implies accurate measurement. Vasari tells us how Brunellesco learnt geometry from Paolo Toscanelli, the greatest mathematician of his time; and how he in turn had taught Masaccio.[1] This scientific basis of naturalism was the one way in which the artists of the early renaissance believed that they might surpass antiquity. In every other respect they were devoted students of the past; for to that generation classical art not only provided a repertoire of forms perfectly controlled and generalised by centuries of attrition, but it showed the way in which art might concern itself with the great issues of human life. With these principles in mind, we can understand why Alberti's dedication does not mention any living painter. The vast majority were still using the Giottesque-gothic style, of which Giovanni da Ponte's altarpiece, probably painted in 1435 [5], is typical. And the few great artists whom we think of as exponents of the

[1] Alberti's *Intercoenales*, satirical short stories or fables, were dedicated to Toscanelli.

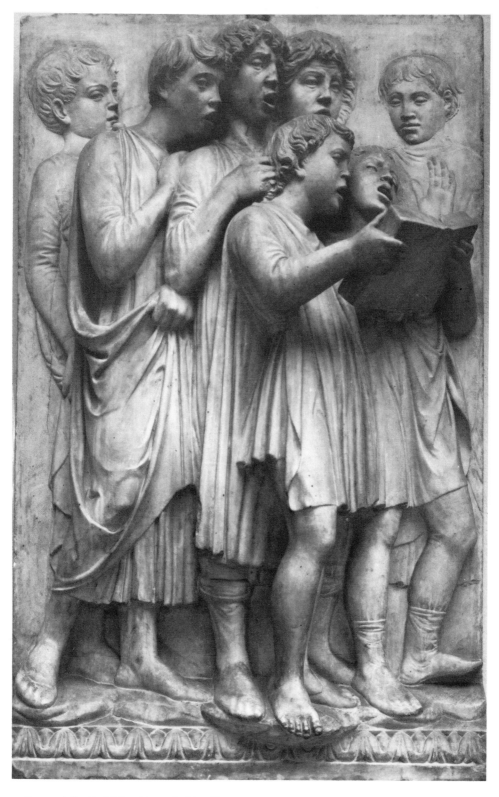

4 Luca della Robbia, *Cantoria* (detail), 1431–38

new principles only mastered them ten years after the *della Pittura* was written. The Blessed Angelico, for example, who was to show a subtle sense of space composition in his frescoes in San Marco,[1] was at this time still using the bright colours and gold backgrounds of an illuminator. Uccello, who was in Venice when Alberti was writing his treatise, had hitherto worked in a fanciful Gothic style, in which practically no traces of classical or scientific interest are perceptible.[2] As for Fra Filippo Lippi, who seems to have been a pupil of Masaccio, in 1434 he was in Padua, a young and comparatively obscure painter, and although by 1438 he was back in Florence and fully employed[3] we can be sure that his work would not have satisfied Alberti: and in the end he was the artist who more than any other transmitted to a later generation the tradition of linearism. So the omission of contemporary painters from the dedication of the *della Pittura*, though paradoxical, was inevitable, and thanks to the wholly pictorial style of the sculptors, it does not affect the contemporaneity of Alberti's arguments, except where he comes to speak of colour. Later in life he was to find one painter who fulfilled his ideals and with whom he became intimately connected: but in 1435 Piero della Francesca was a provincial youth, not yet even apprenticed to Domenico Veneziano.

I began by calling the *della Pittura* the first treatise on painting ever written. In reading it we must constantly keep this in mind; and in fact Alberti does not allow us to forget it for long. 'Noi vero i quali', he says, 'se mai da altri fu scritta, abiamo cavata quest' arte di sotterra; o se non mai fu scritta, abiamo tratta di cielo'. In so far as others have written on art

[1] The frescoes in S. Marco are of a much later date, since the Dominican Brotherhood only received the Convent in 1436, and it was not till 1443 that Michelozzo's work was completed.

[2] Immediately after his return in 1436 he showed a knowledge of classical architecture and perspective in his memorial portrait of John Hawkwood in the Duomo; but his practice cannot have influenced Alberti's theories. How far the influence was the other way is discussed below, p. 102–3.

[3] See the letter from Domenico Veneziano to Pietro de' Medici in Gaye's *Carteggio*, p. 136.

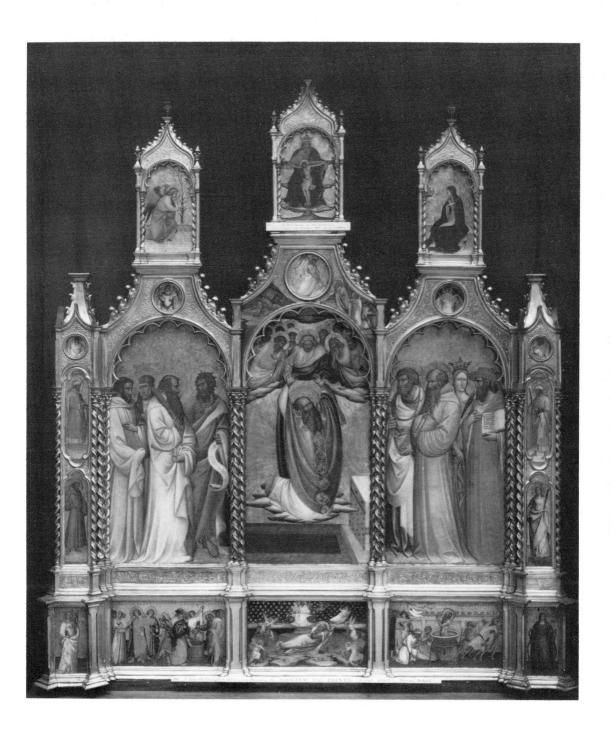

5 Giovanni da Ponte, *Altarpiece*, early 15th century

their thoughts have lain buried; and as for those things which have never been written, he has drawn them from the sky. And the book ends with a claim that its imperfections must be excused on account of its complete originality—*nulla si truova insieme nato et perfetto*. Let those who come after with greater wits and learning write a book on painting *absoluta et perfetta*.

The reference to writings on art *cavata di sotterra* must refer to Pliny, a manuscript of whose works, bought in Lübeck by Cosimo de' Medici on the advice of Niccolò Niccoli, had recently been made accessible in Florence.[1] But although Alberti often quotes from Pliny's gossip in illustration of his points, he is conscious of a higher and more difficult aim, 'non come Plinio recitiamo storie', he says, 'ma di nuovo fabri- chiamo un' arte di pittura'. It is this aim which distinguishes Alberti's *della Pittura* from two other books on painting which were written in the next decade, Cennino Cennini's studio receipt book and Ghiberti's *Commentarii*.[2]

The *della Pittura* opens with a series of definitions in mathematical terms. True, Alberti tells us on the first page that he is writing *non come mathematico ma come pictore*, but much later in the book in speaking of the education of the painter he returns to the subject, and says categorically that 'no painter can paint well without a thorough knowledge of geom- etry'. The reasons for this mathematical knowledge are twofold. First, the painter must have some scientific understanding of what he sees; and secondly, he requires geometrical knowledge to set it down correctly. And what does he see? Alberti believes that he sees a section of a pyramid of vision from which the rays converge on the eye. 'And this', he says, 'is the painter's purpose, to render in outline and colour on a flat surface, whether a panel or a wall, those parts of any objects which present

[1] See Vespasiano de' Bisticci, Life of Niccoli. The manuscript is now Riccardiana No. M. II, ii, 488. It was, of course, the inspiration and model of Ghiberti's *Commentarii*.
[2] Cennino Cennini's book dates from 1437. The *Commentarii* are a work of Ghiberti's old age, and date from 1447.

themselves to the sight in such a manner that at a given distance and in a given position they will appear to be in relief, and very similar to the said objects.'[1] The implications of this definition are worth following up. First there is the insistence on a given distance and a given position, which is the necessary consequence of the visual pyramid. The data of sight must be brought under control: and herein lies the superiority of painting and low relief over sculpture in the round, where the spectator is free to choose his own point of view, and so abandons some of the scientific perfection of art. While on this point Alberti refers many times to his invention of a squared screen—he calls it a *velo*—which placed between the artist's eye and the section of the visual pyramid made it easier to give objects their precise position in space. Such a screen was, in fact, much used by painters of the high renaissance, especially in dealing with problems of foreshortening. Dürer and Holbein have left us representations of it, and there can be little doubt that it was responsible for the amazing precision of Holbein's portrait drawings. The objection, which seems valid to us, that it ties the artist down to a oneeyed, static viewpoint, was a recommendation to Alberti; 'nor do I give any heed', he adds, 'to those who say that it is bad for a painter to accustom himself to these helps; for surely what we want from him is not that he should undergo infinite labour, but that he should give us a picture in high relief'—*quale molto paja rilevata*.

Ritondo et rilevato—these are the words which recur again and again in the first part of the *della Pittura*. They are essentially a Florentine criterion of excellence, as a great critic of Italian art perceived when he said that the chief aim of Florentine painting was the realisation of tactile values. But there was another aim, linear grace, which preceded and followed the age of Masaccio; and when Alberti writes, 'I say that learned and unlearned alike will praise those heads which appear to stand out from the picture as

[1] p. 143. A similar definition is on pp. 70–1.

if they were sculptured',[1] the note of defiance in his voice is directed against the ordinary workshop picture of his time, in which the face is little more than a conventional hieroglyphic; or against such an artist as Lorenzo Monaco, in whose work modelling is subordinated to pattern, naturalism to style.

In opposing the practice of Gothic mannerism Alberti often comes near to praising mere imitation for its own sake. True, there are many passages in which the doctrine of realism is modified on stylistic and philosophic grounds. But underlying all Alberti's theories is the assumption that painting is concerned with the accurate representation of the visible world; and unfashionable, perhaps unreasonable, as this may seem to us, we must not try to hide it under a cloud of philosophy, saying that by imitation Alberti meant 'creating an organism analogous to those created by nature', and similar graceful sophistries. Throughout history revolutions in art have taken the form of a return to nature against exhausted formulas of picturemaking, or an excessive attachment to style for its own sake. All true revolutions are popular and antihierarchic, and ultimately popular art is always realistic art. That modern abstract art should be called 'bolshevik' is a comical misnomer; far from being the art of the *bolshoi*, the many, it is the art of the very few, and in any thoroughgoing revolution it would be swept away. It could be correctly described as anarchic, contrary to the old laws, and so entirely subjective. All this must be remembered when we look at Alberti's *della Pittura* from the point of view of modern art, for his position is the exact reverse of our own. He and his friends were truly revolutionary in their insistence on realism, but they also claimed, as so many revolutionaries have done, that they had the authority of the old laws.

The first book of the *della Pittura*, which deals almost entirely with the science of vision and the means of rendering the base of the visual

[1] p. 133. Cf. in this connexion the roundels in the Duomo, Florence, painted by Uccello in 1443.

pyramid by planes and outlines, is heavy going. The language is both dry and obscure, and at the end of the section Alberti admits that it will be read *con fastidio*. But he adds *quello che seguira credo sara meno tedioso*. This is correct. On almost every page the pencil hovers to mark or annotate some revealing or penetrating passage, or some almost incredible anticipation of classic theory. Alberti's *della Pittura* is the prophetic book of academ⁄ism. There is practically no part of academic teaching during the next four hundred years which does not lie, compressed but calculated, in its pages. It was Alberti who first felt that painting must be rescued from the position allotted to it in the medieval⁄aristotelian scheme among the mechanical arts. As a humanist and a student of Plato he believed in the absolute supremacy of the mind, and he set out to prove that painting was essentially a mental and not a manual activity, 'che l'arte del dipignere sempre fu ad i liberali ingegni et a li animi nobili dignissima'.

We must confess that like all those who since his time have attempted to raise the status of the arts, Alberti lays an emphasis on cultivated and easy manners which is distasteful to a more romantic age. There are times in reading the *della Pittura* when the image of a bland old gentleman in a wig giving away prizes to successful students entirely supersedes that of the taut and fiery Florentine. But we are soon recalled to the fifteenth century by some tough scientific proposition, drier and knottier than anything which could have flowed from the pen of Sir Joshua, when the more indigestible elements of Platonism had been conveniently pulped. The difficulties of the first book, for example, are largely due to a Platonic desire for a close union of art and mathematics. With two of the classical doctrines which underlie the rest of the treatise, however, the eighteenth century would have been completely at home. These are ideal form and the historical subject⁄matter. The importance of these concepts in the thought of the next three centuries is so great that they require fuller treatment.

That the artist must discover an ideal beauty which lies, immanent but

overcast, in the imperfect forms of nature is perhaps the most rational doctrine of aesthetics ever propounded, but it has suffered from a too literal application. As Bacon said, 'a painter may make a better face than ever was, but he must do it by a kind of felicity (as a musician that maketh an excellent air in music) and not by rule'. In academic teaching, which after all depends on rules, the doctrine deteriorated into what Professor Whitehead calls the mathematical fallacy, that beautiful parts add up to a beautiful whole, and from this fallacy Alberti was not altogether free. He relates with approval Pliny's story of Zeuxis and the five comely maidens of Croton. But it is fair to say that his strong sense of realism saves him from the more abstract applications of the theory which diluted the practice of the eighteenth century. He realised for example, that a face made up in the mind is insipid, and adds the shrewd observation that in a group a portrait head will always take the eye and lead it away from the other heads, even although the ideal heads are *più perfette et grate*. This is a statement which we can check for ourselves from a work of Alberti's own time, Masaccio's fresco in the Carmine, where the portrait heads added by Filippino, although in a lower style than the Masaccio, immediately attract our interest to the detriment of the composition as a whole.

The importance of subject-matter is treated more fully. Alberti believes that it should be of such a character 'che sola senza pictura, per se la bella inventione sta grata', and he gives two examples of such subjects drawn from Pliny, one of them the famous Calumny of Apelles. Here we encounter for the first time symptoms of a disease which afflicted European art in the next four hundred years: the disease of *ut pictura poesis*. And the accident by which antique painting, with its immense prestige, was known only through second-hand descriptions in Pliny, led to academic painters giving more attention to what would read well than to what would look well. But here again Alberti's academism stops short of the pedantic elaborations of the eighteenth-century classicists, and the subjects he describes are designed to please the eye. He praises copiousness

and variety, for as in food and music there is an immediate pleasure in variety and abundance, and he commends a scene in which are mixed 'vecchi, giovani, fanciulli, donne, fanciulle, fanciulini, polli, catellini, uccellini, cavalli, pechore, hedifici, province et tutte simili cose'. We are reminded more of Bassano at his most extravagant than of Alberti's austere contemporaries, until we remember that Ghiberti's relief of Solomon and the Queen of Sheba contains eighty-nine figures and seven animals. And in fact Alberti at once contradicts the Bassanesque impression by saying that such copiousness must be relevant to the subject and must be contrived with dignity and discretion, and that the figures should move 'with a certain beautiful agreement towards the main subject of the action'.

'A history', says Alberti, 'is moving when men express in actions the motions of their minds. For we are so formed by nature as to sympathise with what we see, and we can only perceive the motions of the mind through the motions of the body.' Then follows a passage on expressive gestures which, as we shall see, deeply influenced Leonardo, and Alberti goes on to recommend that the gestures shall be so designed as to lead the eye in all directions—some pointing in, some out, some leaning to one side, some to another, some looking up, some down. The passage is elaborated till once again we are reminded of compositions of a far later date—this time of the frenzied pointing and posturing which the immense prestige of Raphael's later style inflicted on historical painting for three centuries. We must keep our historical perspective and recognise that compared to a row of *trecento* dummies even the grave and deliberate gestures of Masaccio would seem full of animation; and in fact Alberti himself is careful to warn us against over-emphatic movement and a *contraposto* so great as to show the breast and reins at the same time, by which the figure becomes like a fencer or an acrobat, without the dignity proper to painting. In the high renaissance conflict between classicism and mannerism we can be sure that Alberti would have been a classicist;

but what, we wonder, was he thinking of in 1435, long before the time of Pollaiuolo, Botticelli, Filippino, and other early masters of twisted movement?

For, try as we will to illustrate Alberti's *della Pittura* by works of his own time, the images which it conjures up in the mind's eye all come from the painting of the next century. Nor is it a mere accident that when we read his descriptions of subjects and rules of composition we are reminded of the works of Raphael. To begin with there is the remarkable fact that all the subjects he describes are drawn from classical literature. Not once does he mention a Christian theme, although in 1435 scarcely a single picture of a pagan subject had yet been painted; and when, a few years later, illustrations of classical legend began to make their appearance in the circle of Domenico Veneziano they were closer in spirit to the *Histoires de Troye* than to the *Iliad*. In detail, too, there is much in Alberti's treatise which was not realised until seventy years after it was written—for example, his advice on the nude and on the treatment of drapery. 'In painting the nude', he says, 'begin with the bones, then add the muscles and then cover the figure with flesh in such a way as to leave the position of the muscles visible. It may be objected', he adds, 'that a painter should not represent what cannot be seen, but this procedure is analogous to drawing a nude and then covering it with draperies'. This is a description of Florentine academic practice in the sixteenth century. But there were no such nudes in the painting of 1435, when Castagno had not begun his studies of anatomy. The naked figures in Masaccio's frescoes, although superbly realised, do not show a schematic anatomical approach. As to draperies, he tells us that, in order to counteract their natural tendency to fall in straight lines, they should seem to be blown by the wind, so that on one side the nude body is revealed, while on the other the draperies flutter in the air with a graceful movement. Both these details indicate a source of Alberti's *della Pittura* which we have not yet examined, the remains of antique sculpture.[1] (p. 97).

The extent to which antique art was visible in the early Renaissance is a subject by itself. Although excavation had hardly begun, we know from descriptions and from one or two contemporary sketch-books that many specimens, including, of course, the triumphal arches and columns, were to be seen in Rome. We know too that Alberti's friends, the humanists, vied with each other as collectors of antiques. Niccolò Niccoli had a small gallery containing marbles, coins, and a famous engraved chal-cedony; and Poggio had an even more important collection, partly discovered in the Campagna, partly bought from Greece, where he employed as agent a Franciscan named Francesco di Pistoja. Ghiberti and Donatello both had famous collections, and Donatello had brooded on classical sculpture until it became a part of his style. But Donatello's assimilation of antiquity was unique.[1] In the work of other artists of the *quattrocento*, even in that of Ghiberti, classical forms appear like quo-tations, rather self-consciously in inverted commas. Take the two examples already given, the anatomical nude and the wind-blown draperies. We feel at once that the graceful Hercules on Ghiberti's door is a show piece, exhibited for the delight of connoisseurs, and the Maenads in fluttering draperies who appear among the placid bourgeoisie of Ghirlandaio have obviously blown in from another world. It took almost a hundred years for the forms of antiquity to be assimilated into the art of the renaissance, but Alberti, in his description of antique subjects, had to undergo no such difficult process of digestion and re-creation. He could reach in a few years a point of view which was only achieved by painters after the all-absorbing genius of Raphael had created a new universal language of classicism. It is fair to Alberti to add that in his own

[1] (p. 96) Very few fragments of antique painting had as yet been excavated; cf. Castiglione's *Cortigiano*, ed. *princeps*, p. 80. The most famous example, the *Nozze Aldobran-dini*, was discovered in about 1600.

[1] Vasari recognises this when he says in his introduction to the second section of his book that he had almost put Donatello in the third because his works are the equal of good antiques.

architecture he achieved a mastery of classical form as great as that which he advocates in his writings. So that when, in reading in the *Architettura*[1] his advice on how to adorn a palace with painting, we can think only of Giulio Romano's decorations in the Palazzo del Te, it is not an anachronism but a *vraie vérité* justified by the facts.

In quoting the authority of classical art Alberti is arguing from sculpture to painting. It was a process which did not greatly affect his argument, for, as we have seen, he considered sculptured and painted relief as practically the same art. But there was one element in painting which could not be treated in this way, and that, of course, was colour. In consequence the passages devoted to colour are not dependent on classical authority, or even on the practice of his time, but are the direct result of his own observations. Alberti completely abandons the symbolic and decorative conception of colour which had held good throughout medieval art, and instead treats of colour as identical with the reception of light. It is an entirely visual approach which aims above all at truth of tone. The painter must seek for tones with half-shut eyes, he must paint within a limited range which allows greater truth. Absolute black and white are inadmissible; even the whitest vestments must not be painted white, for white is all the painter has to render the lustre of a polished sword, and black is all he has to show the ultimate darkness of night.[2] There are those, he says, who use much gold in their compositions, believing that it gives grandeur: *non lo lodo* — I do not praise it. And with perfect logic he points out that even if the objects to be represented are of gold the whole effect must be rendered in paint, for if real gold is used it will reflect the light, and disturb the atmospheric unity of tone. In 1435 there was no painter working who did not make use of gold in his panel pictures,

[1] *Architettura*, bk. ix, ch. 4.

[2] All painters know that it is easier to keep tones under control if the general tonality is dark. But Alberti gives another and curiously characteristic reason for his advice: that we naturally prefer what is light and so must be at greater pains to guard against this error.

altarpieces, or *cassoni*. Masaccio himself had used a gold background in the Pisa polyptych, and ten or fifteen years later, when gold was no longer fashionable in backgrounds and skies, it was still used for nimbs, dresses, and accoutrements. Alberti's conception of colour as a function of light is first apparent in the backgrounds of Fra Angelico's later works and in Domenico Veneziano's Uffizi altarpiece, which must date from about 1450. One panel from its predella in the Fitzwilliam Museum shows a sunlit wall and garden, which have been rightly recognised as the first passages of *plein air* painting in post-classical art. Domenico's great pupil, Piero della Francesca, in his delicate sense of atmosphere as in much else, was the realisation of Alberti's hopes and theories. But even in Piero there is a flat, decorative use of colour and a love of blacks and whites which Alberti's severely naturalistic conception of tone would not allow. And it is clear that his theories were not related to any painting earlier than the seventeenth century, but to his own *miracoli della pittura*, the images projected in his little box.

Once more we are aware of the conflict between a scientific and a stylistic approach, a dilemma which does not seem to have troubled Alberti, but which underlies the whole of the *della Pittura* in the same way that a conflict between his realistic Tuscan business philosophy and the teachings of Plato underlies his moral writings. In the event it was the classicising and stylistic part of Alberti's writings, and not his scientific naturalism, which was realised in the painting of the next hundred years. No one attempted to follow his advice on tone and colour, but where academic procedure is concerned he anticipated the smallest details. I have already shown how this advice on the nude and drapery and expressive gesture was carried out by Raphael and his pupils. A few other details are worth noting. A student should draw larger than sight size (*quattrocento* drawings are usually slighly smaller) as in that way errors are more easily corrected. He must measure the figure by the number of heads it contains, not as hitherto by the feet. He must correct his drawings by

looking at them in a mirror, and parts of the body *quali porgono poco gratia* must be covered with leaves or a wisp of drapery.

As so often in studying Alberti our admiration at the extraordinary clarity and authority of a mind which could anticipate and impose itself on subsequent centuries is clouded by the knowledge that many of these doctrines have, by their reason and rigidity, had an unfortunate effect on European art. His advice to draw big, for example, though it has been disregarded by almost all great European draughtsmen, has resulted in thousands of mediocre drawings where an artificial inflation of scale has deprived the artist of the saving grace of sincerity. A similar error of academic teaching is contained in his suggestion that the student should learn the human form like a language, in which the features and members are like letters and syllables a course which led to those dismal collections of 'correct' eyes, ears, and noses which, beginning with the Caracci, were published by academies of design throughout the seventeenth and eight-eenth centuries. But for these misfortunes we must not blame Alberti so much as the impossibility of laying down laws for the conduct of art. Even if the *della Pittura* had not existed, the formulating tendencies of later classicism would have reached similar conclusions.

The *della Pittura* also had a direct influence, although this has not hitherto been connected with the name of Alberti. There is no doubt that it was known to Leonardo da Vinci, who made great use of it in the notes on painting afterwards collected under the title of *Trattato della Pittura*. This fact has usually been denied or evaded by Leonardo scholars, and if similarities were confined to general theories we might agree that both were expressing current Florentine assumptions. There is, for example, nothing conclusive in the fact that both insist on the student being proficient in mathematics, or that both agree that the first aim of painting is relief. 'La prima parte della pittura è che i corpi con quella figurata si dimostrono rilevati.'[1] But when we come to the parts of Leonardo's *Trattato* which deal with composition, expressive gesture, the conduct of

draperies, hair, and other questions of picture-making we find not merely similar advice but identical images and, in some cases, identical lan-guage. The description of a copious and varied composition, quoted above, with its slightly comical catalogue of staffage and its final com-mendation of dignity and decorum, is copied almost word for word in the *Trattato*;[1] the passage which follows it on the expression of emotions by means of action is only slightly rearranged and translated into a more modern Italian.

Not to encumber these pages with parallels, let me quote one passage from Alberti which even those who have not made a special study of Leonardo will recognise as peculiarly Leonardesque. 'In the rendering of hair, of branches and leaves and of draperies it delights me to see some movement. Hair should turn upon itself as if to form a knot, should curl up into the air like a flame, or glide like a serpent, flowing this way and that'.

All the passages quoted from Leonardo's *Trattato* are to be found in the Ashburnham Codex of 1490, and it is evident that when he was compiling this manuscript, Leonardo had a copy of Alberti's *della Pittura* beside him. As usual his note-book contains a mixture of original observations, ideas derived from other authors, and actual quotations. Take, for example, the notes on drapery in the Ashburnham Codex.[2] Their point of departure was the passage in the *della Pittura* already referred to; but Leonardo has amplified from his own experience Alberti's terse and categorical statement, so that his notes have an entirely different character. Leonardo was in general far less academically minded than Alberti; he had less admiration for antiquity, and even when

[1] (p. 100) Cf. *Trattato*, par. 133. I give references to the *Trattato* by paragraphs, so that any edition may be consulted. Where there is a substantial difference between the text of the *Trattato* and Leonardo's original notes, reference will be made to Richter's *Literary Works of Leonardo*, 2nd ed., also by paragraph.

[1] *Trattato*, pars. 117, 118.

[2] Quoted in Richter, pars. 390–2.

quoting from the *della Pittura* he omits the references to classical art. His study of the science of vision is more scientific and more explicit and he carries much farther Alberti's notes on colour and reflected light.[1] In every way the *Trattato* is the product of a more observant eye, a richer and more astonishing personality. Yet the debt to Alberti's *della Pittura* is immense, and is particularly apparent in those parts of the *Trattato* which affected seventeenth- and eighteenth-century opinion. When we consider the influence of the *Trattato* on the Caracci, and on Nicholas Poussin, who actually illustrated it with his drawings, we realise that Alberti's short treatise was not only the prophecy but the source of academic theory.

Compared to its influence on subsequent theory, the effect of the *della Pittura* on contemporary practice was small, and cannot be proved by any documentary evidence. But on internal evidence there are very strong grounds for believing that it influenced profoundly two of the leading artists of Alberti's generation, Paolo Uccello and Piero della Francesca. A simple way to estimate its effect on Uccello is to compare the two series of frescoes from his hand in the cloisters of Santa Maria Novella. The first, representing the Creation and Fall of Man, must date from soon after 1430; the second, representing the Deluge and the Drunkenness of Noah, was painted between 1444 and 1446.[2] Although the Creation and Fall were executed some years after the work of Masaccio and Masolino in the Brancacci chapel they show no consciousness of the new humanist style. Uccello reveals himself as a follower of the Gothic tradition both by the rhythm of his draperies and by the tapestry of flowers and leaves in which the action is set. There is no attempt to achieve depth by scientific or any other means. In the later scenes the contrast is complete. The Deluge [Uccello 13] has always been recognised as the

[1] Cf. *della Pittura*, pp. 67, 135; and *Trattato*, pars. 458–79.
[2] A generation of critics which was unable to reconcile Uccello's Gothic style with their preconceived notion of his character as an artist doubted that the earlier frescoes were from his hand, in spite of the documentary evidence which supported them.

most naïvely doctrinaire of all attempts to apply the science of perspective to art. The composition of the two arks is almost like a diagramatic illustration to Alberti's first book; but even more Albertian is the fact that Uccello has tried to unite this scientific approach with copiousness, variety, and drama. Here is the bewildering accumulation of persons and animals, which I compared above to Bassano, here is the range of emotion expressed through gesture. And two details are worth noting. The composition which Alberti praises as fulfilling his ideals is that of Giotto's 'Navicella', and he describes it in terms which may have induced Uccello to try his hand at a still more dramatic effect of ship-wreck. Secondly there is the curious fact that Alberti in the passage on wind-blown draperies already quoted advises the painter to include the face of a wind-god blowing in order that the source of the wind may be established. It was bad advice for a naturalistic painter, and as far as I know was not followed till the period of classicism. But Uccello, the least classical of painters, has included a wind-god, most inappropriately, in the background of his Deluge. I need not emphasize the Albertian elements in the scene of Noah's Drunkenness, the foreshortening, *con-traposto*, and animated gestures; these are the qualities which were ad-mired by Vasari and other critics of the high renaissance. But they are not the qualities for which we admire Uccello, and in fact they are not of his essence. As Alberti's influence recedes, his natural love of pattern reas-serts itself, perspective becomes no more than an adjunct to decoration, and a world of legend and heraldry takes the place of what used to be called scientific naturalism. The last Uccellos, like the *Hunt in a Forest* at Oxford [Uccello 22], are almost as Gothic as the first. Critics who have been puzzled by this unevolutionary sequence have not thought of the *della Pittura*; but without the influence of theories such as it contains Uccello's development is incomprehensible; and in view of Alberti's position in Florence the chances that Uccello read his book and knew him personally are extremely high.

With Alberti's influence on Piero della Francesca we are, fortunately, out of the realm of conjecture, for the two collaborated in the Tempio Malatestiana in 1450, when Piero painted his fresco of Sigismondo Malatesta with an architectural surround designed by Alberti. Thenceforward all Piero's architectural backgrounds show Alberti's influence and are, I believe, most valuable evidence of his unfulfilled ideals and projects. We may imagine too that Piero's paintings must have been for Alberti a source of great consolation in later life. For by 1460 the achievement of Florentine art which he so greatly admired in 1435 had been superseded by another fashion. Lightness, grace, and decorative fancy had replaced the *pietas, gravitas,* and *humanitas* of Masaccio and Donatello. In these years the only painter who maintained the majestic tempo and the mathematical harmonies of the older generation, the true heir of the first Florentine renaissance, was Piero della Francesca; and it is no accident that, in spite of his great authority, he was never once employed in Florence. In between the first and second heroic periods of Florentine art comes that enchanting episode in the history of the spirit, that unique blending of medieval and classical grace, of which Botticelli was the typical painter, Desiderio the sculptor, Politian the poet, and Pico della Mirandola the philosopher. In this new world of flowers, fantasy, and elaboration Alberti must have come to appear a somewhat archaic figure, admirable and respected by the patron of the new movement, Lorenzo de' Medici himself, but remote from fashionable enthusiasms. True, his love of Plato led him to attend the lectures of Marsilio Ficino, but to his practical mind the self-delighting subtleties of Neoplatonism must have been quite incomprehensible; and in the last, and best, of his moral writings, the *de Iciarchia,* written in about 1470, there is no sign of Neoplatonic influence.

In later life Alberti was seldom in Florence. The scene of the *de Iciarchia* is laid there, and Alberti never ceased to consider himself a Florentine; but in that dialogue he says of his city, 'son ci come forestiere; raro ci

venni e poco ci domorai'.[1] His time was spent in Ferrara, in Mantua, and above all in Rome. He was not, of course, forgotten in mid-fifteenth-century Florence, where his great buildings, the façade of Santa Maria Novella, the Rucellai Palace, and the choir of the Annunziata, were in process of construction between 1450 and 1475; and where his book on architecture was printed in 1485, thirteen years after his death, with a dedication to Lorenzo de' Medici. But his treatise on painting could hardly have influenced artists during this period until reinterpreted by the true creator of the high renaissance style, Leonardo da Vinci. When it was printed in the 1540s[2] it was read by such theorists as Paolo Pini[3] and Michelangelo Biondo;[4] but by that time its doctrines, once so revolution-ary, had become commonplace. And commonplaces they remained for over four hundred years; commonplaces as flat, as true, as dull, and as durable as the the Ethics of Aristotle.[5]

[1] *Op. Volg.* iii, p. 34.
[2] There is a Basle edition of 1540; a Venetian edition of 1547.
[3] Paolo Pini, *Dialogo della Pittura*, Venice, 1548.
[4] Michelangelo Biondo, *Della Nobilissima Pittura*, Venice, 1549.
[5] This essay is based on a lecture delivered to the British Academy in November 1944.

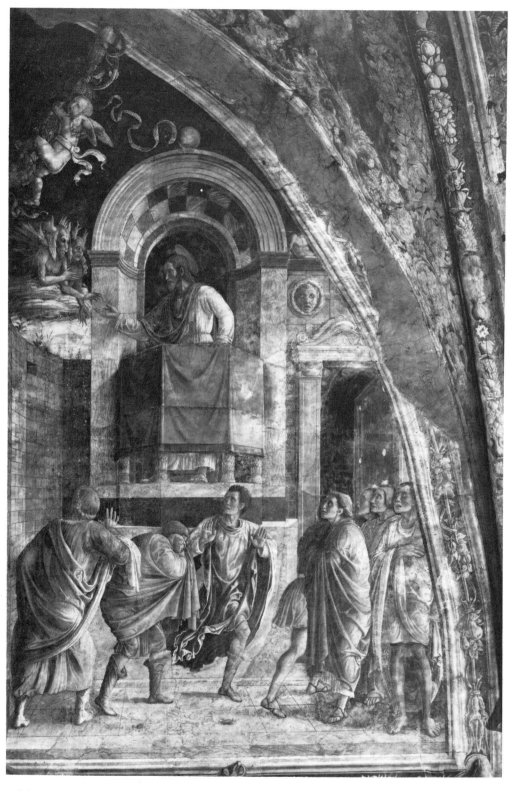

1 Mantegna, *St James addressing the Demons*, 1454–57

4

MANTEGNA AND
CLASSICAL ANTIQUITY

Andrea Mantegna was the first Renaissance painter to create a convinc-
ing picture of classical antiquity. He did so partly by archaeological
study; but far more by his own character, which was perfectly in sym-
pathy with that of republican Rome. He had the gravity, the high moral
sense and the obstinacy of great Roman heroes. In this essay I try to show
how these qualities enabled him to create an image of antiquity which
still influences us today.

We are, as usual, ignorant of the facts of his early life. It seems that he
was born in 1431 in Piazzuola in the territory of Vicenza, but we know
nothing about him until he appears, at the age of ten, as apprentice and
adopted son of Francesco Squarcione, then the chief native painter of
Padua. The town of Padua had a university which had long given itself
antique airs. It practised a somewhat pedantic humanism, very different
from the philosophic humanism of Florence. It contained a few frag-
ments of antique sculpture which were venerated as holy relics. It also
contained, symbolically enough, the supposed ashes of Livy, whose
'tomb' is still to be seen, dusty and neglected, beside the tramlines. More
authentically, Petrarch had given his library to Padua, and spent his last
years in the neighbourhood; and the Carrara family, rulers of Padua in
the fourteenth century, had struck the first commemorative medal in the
antique style. Many famous humanists had taught in the University, the
general tendency of teaching being Aristotelian rather than Platonic.

This veneration for the literature of Greece and Rome was not reflected

in Paduan art. Indeed in the middle of the fifteenth century Padua had
produced no artists of distinction, and the painters who had worked
there, Altichiero in the fourteenth century, Uccello and Fra Filippo in
the 1430s, had all been foreigners. Much the most important artistic event
had been the long residence of Donatello, who remained in Padua from
1443 to 1453, working on the Gattamelata and the altar of the Santo. But
the atmosphere was incurably provincial. Vasari tells us how Donatello
expressed the need to return to Florence, where his work was not praised,
but criticised. And in fact his Paduan bronzes, making all allowances for
the help of assistants, show an occasional falling off in creative power.
The three bronze *predelle*, illustrating the miracles of St Antony, are
indeed masterpieces of the first order. But it we compare the bronze panels
of the Evangelists with the dancing putti on the cantoria of the Duomo in
Florence we see how qualities beloved of provincial art, the prettiness or
quaintness, the decorative detail, the display of craftsmanship, have
replaced the plastic vitality of the Florentine period.

Such, then, was the artistic atmosphere of Padua when, shortly before
1445, Mantegna was working in the so-called academy of Squarcione.
This was itself an example of provincial humanism; and as we read of its
contents we are reminded of the local antiquarian society of, shall we say,
York in the eighteenth century—or perhaps even of the first catalogue of
Tradescant's Ark, the earliest museum in Europe.[1] There were frag-
ments of the antique, incomplete inscriptions, a Byzantine Madonna,
now in the Vatican, and a good many objects of dubious authenticity
which Squarcione had picked up on his travels. From his signed works
we see that Squarcione was provincial, and it is evident from a very full
series of documents that the boy Mantegna was his great discovery;
because Mantegna, like Dürer, was an infant prodigy. This element of
the virtuoso in his art is extremely important. He was one of those for
whom technical uncertainties do not exist, and difficulties have to be

[1] Now the basis of the Ashmolean Museum, Oxford.

artificially created. An example is the triptych in the Uffizi where the central panel is painted on a concave surface, an achievement that is always pointed out to tourists by guides and evokes cries of wonder. It is not, I believe, fanciful to suggest that Mantegna, as he grew older, became ashamed of his skill, and that the extreme austerity of his late *grisailles* was a kind of renunciation of his virtuosity.

By the age of fifteen Mantegna had become a sort of pupil teacher in Squarcione's academy. One of his early, independent commissions he signed with the statement that he was seventeen years old, and shortly afterwards he was amongst the artists chosen for one of the most important public works in Padua, the decoration of the Ovetari chapel in the church of the Eremitani. He was associated with a slightly older artist named Pizzolo, who, however, fell off the scaffolding and was killed in 1453. From thenceforward Mantegna was in complete control, and poor Squarcione was left to rage, lament, calumniate and bring law suits— tiresome for Mantegna, but very useful for the historian, because, as all historians know, our knowledge of the past is based very largely on the records of litigation; and, as Mantegna was a tireless litigant, we know an unusual amount about him at all periods.

The documents relating to the Ovetari chapel are of baffling complex⁄ity, and have been the subject of argument between Italian scholars of almost Mantegnesque acuity. Personally I am convinced that the six scenes from the life of St James are all by Mantegna, and show the development of his style between the age of nineteen and twenty⁄six. At first it owes something to Fra Filippo, who had been in Padua in 1434, but it already has the character which we associate with the mature Mantegna; and already, in the *St James addressing the Demons* [1], there is an interest in perspective and classical architecture. These characteristics are even more remarkable in the next of the series, *St James Baptising* [2], where the architecture must surely owe something to Leon Battista Alberti.

The use of perspective is often attributed to the long residence of Uccello in Venice and Padua, but Uccello at that date had not become a master of perspective, and at no time was he interested in classical architecture. That it did not need the physical presence of Uccello or anyone else, to bring such ideas to North Italy and the Veneto, we can see from the drawings of Jacopo Bellini. The two volumes in which these have survived, in the British Museum and the Louvre, are an indication of how little we know about the sources and movement of ideas in Renaissance art. Had they been destroyed, as so many hundreds of similar collections must have been, we could never have guessed that Jacopo had such wide interests and inventive powers. In his paintings he seems little more than a Venetian hanger-on of the successful Gentile de Fabriano. And yet, as we see from his drawings, he was a student of antiques, a devotee of perspective, with a passion for elaborate architecture and a personal sense of landscape. He had been in Florence with Gentile in 1423, and had seen the first doors of Ghiberti and the early work of Donatello; and he must have kept in touch with these and other Florentines, especially Castagno, in the years that followed. In the ordinary way it would be unwise to use the chance survival of Jacopo's scrap-books as evidence of his influence on Mantegna. But by the time of the later Ovetari frescoes, Mantegna had married Jacopo Bellini's daughter, so we can at least say that drawings like these, by Jacopo or by his sons, were being made and discussed in Mantegna's family circle, and account for such a composition as the *St James Baptising*.

When we come to the scene beside it, the *St James before Herod*, the position is different. Jacopo Bellini treated antiquity, as all the Venetians were to do, with warmth and freedom. The spirit which was to culminate in his son's masterpiece, the *Feast of the Gods*, is present in his pagan fantasies. Mantegna's approach is far more serious. In the *St James before Herod* we can almost describe him as a 'humanist' in the original, narrow sense of the word, as a man who attempts to establish the correct

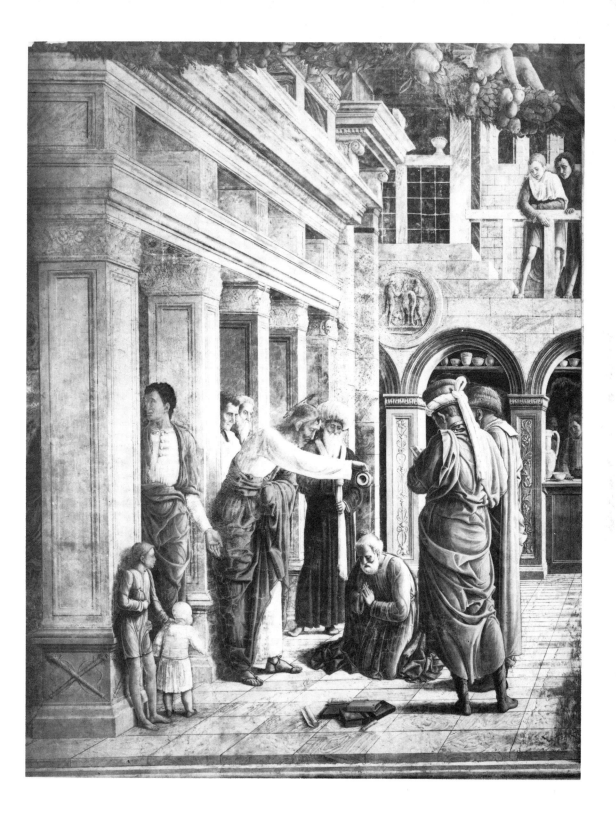

2 Mantegna, *St James Baptising Hermogenes*, 1454–57

text of an antique author. Mantegna has attempted, by learning, to
reproduce an accurate picture of classical items and, although of course
there is much which we now know to be incorrect, the whole carries
conviction. It is interesting to find that at the same date in Florence, the
reputed centre of humanism, a serious scholar could accept the scenes of
antique history painted by Apollonio di Giovanni in a *quattrocento*
costume, which makes them into sprightly decorations, like a pack of
tarocchi cards. Renaissance artists were fond of putting triumphal arches
in the background of their pictures; but they had always looked as if they
had been left over from a different epoch. Not only is Mantegna's arch
incomparably more convincing, but it seems to belong to the same
imaginative world as his Roman soldiers in the foreground. The whole
picture is 'written in latin'. This striving for archaeological accuracy had
in it an element of moral rectitude. Mantegna knew that St James lived in
Roman times and he was determined to tell the truth about them, down
to the smallest particular. The fantasies of Apollonio di Giovanni he
would have considered irresponsible. It is possible that this effort of
learning and moral responsbility has prevented him (at the first attempt)
from achieving certain other qualities: there is a lack of dramatic con-
centration and even some uncertainties in the disposition of space.

But these difficulties, and many more beside, are conquered in the
scene of *St James led to Execution* [3]. Instead of the diffuseness and
uncertainty of the trial scene, it shows intense dramatic power and unity;
and instead of the somewhat dead antiquarian look of the Roman
centurions, the figures are full of movement. This, too, is 'written in
Latin', but with a vitality which surpasses almost all its models.

And what were his models? Art historians have tended to shirk this
problem, and at first sight it seems insoluble. The antiques in Padua were
fragmentary and of poor quality. There were the two *putti* at Ravenna
which Fozzetta had tried to buy as early as 1335, and which were later to
inspire Titian. A few more were to be found in Venice, chiefly decorative

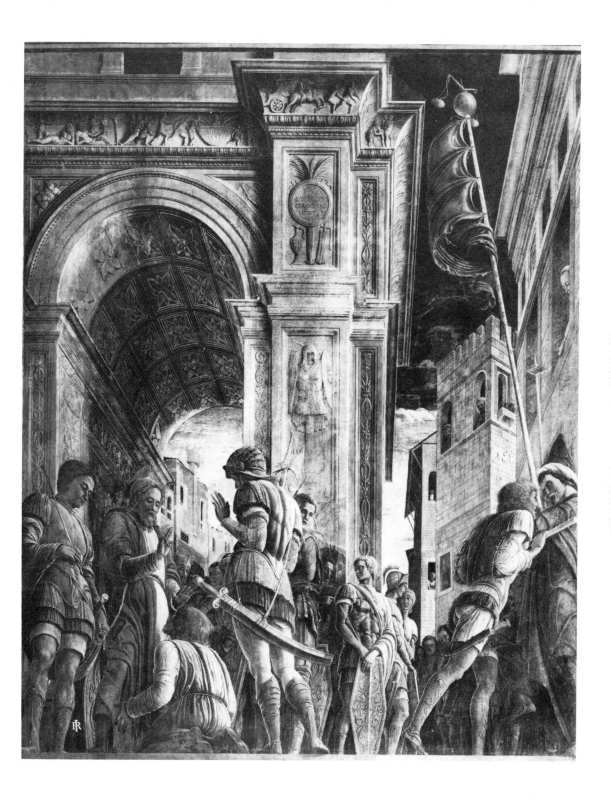

3 Mantegna, *St James led to Execution*, 1454–57

pieces like the Grimani altar, and there were the arches at Rimini and Verona, which must surely have been the chief sources of Mantegna's inspiration. But when he started work on the Ovetari chapel he was little more than a boy, and had always been fully employed. He cannot have travelled much—certainly he cannot have been to Rome.

However, the more we study the classicising artists of the early Renaissance, in particular Ghiberti and Donatello, the more we realise what a mass of material drawn from antique sculpture was available for their use in the form of pattern books or studio books. Such studio books had been a great feature of north Italian art in the late fourteenth century, and several have come down to us. They contained birds, animals, flowers and heraldic devices, the favourite properties of late Gothic art.[1] We also have a number of studio books of the late fifteenth century, and they contain a certain number of antique sarcophagi, cornices and friezes.[2] What we lack is a studio pattern book of the early fifteenth-century Florentines, and perhaps they were always rarer or more jealously guarded. But we can infer their existence unmistakably from the repetition of motives in Ghiberti.

If this is true of a fundamentally Gothic artist like Ghiberti, it is even truer of Donatello, whose use of antique motives was more frequent but less literal. During the first five years of Mantegna's work on the Ovetari chapel Donatello was still in Padua, and his influence on Mantegna has often been pointed out. Even so, I think it has been understated. I find that the whole of Mantegna's evolving style in the years 1450–1454 can be referred back to Donatello, and would offer as evidence the terracotta relief in the Victoria and Albert Museum, and the *Miracles of St Anthony* from the Santo altar, where sense of space, movement, grouping and the whole spirit quite clearly anticipate Mantegna. Now if he was so close to

[1] The fullest are the volumes in the Louvre and the 'sketch book' of Giovanni de' Grassi in Bergamo, which is itself a compilation of other scrap books.
[2] The most famous is the Codex Escurialenses in Madrid.

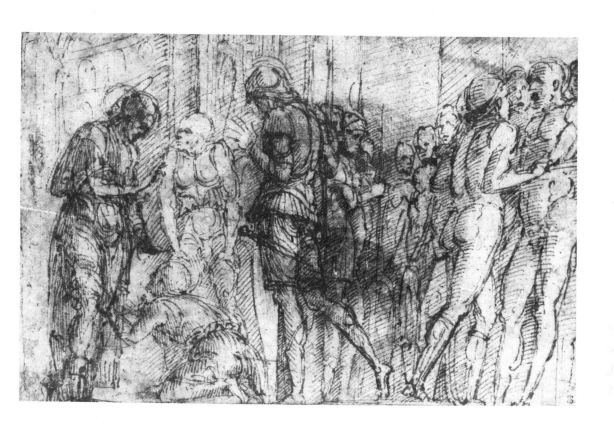

4 Mantegna, Drawing for *St James led to Execution*, c. 1454

Donatello as this, I think it is fair to assume that he would have had access to his studio pattern books, and for all we know to books of drawings quite as audacious as those of Jacopo Bellini. A few early copies show us the style in which they were done, and it is interesting to find in them the peculiar system of notation which appears again in Mantegna's drawing for the *St James led to Execution* [4].

What drawings of ideal Roman architecture must lie behind Donatello's *Salome* relief, drawings no doubt based on studies made when he was in Rome! I believe it was these drawings, either the originals or studio-book copies, that first inspired the young Mantegna with that vision of ancient Rome which was to haunt him all his life. I think it is even possible that he learnt from Donatello another feature of this fresco which is thought to be an innovation: I mean its audacious scheme of perspective. The two lowest frescoes on the wall are in conventional perspective in what is called illusionist perspective—that is to say the figures appear as they would to the spectator if he were looking up at them from below. This daring innovation appears first, as far as I know, in one of Donatello's roundels on the ceiling of the sacristy of San Lorenzo. There the effect is as romantically evocative as a Piranesi. But in the Mantegna it is used to increase the feeling of antiquity. Whether or not perspective was known in Hellenistic painting—Brunelleschian perspective—perspective of the measured hollow box was unknown, and unthinkable: and that is one reason why in the *St James before Herod* imaginative and formal consistency are not quite achieved. In the *St James led to Execution* the perspective sustains the illusion of a direct visual experience. We look up at the figures as we do at the reliefs on a frieze, and it is only after a second or two that we realise that Mantegna has done what antique sculptors never attempted, rendered all the figures themselves in foreshortening. To fill the upper half of the picture space he has put this architecture in the steepest perspective, which, by its rush of lines to a vanishing point outside the frame, increases our emotional partici-

pation in the scene. But he evidently thought the effect too overpowering to be repeated, and in the companion scene he has got rid of the difficulty of the low vanishing point by making the ground rise steeply behind the figures so that the upper half of the picture is filled with one of Mantegna's characteristic hills, where the rocks fit as neatly as in a Roman wall. Half way up it is another triumphal arch leading nowhere, and crowned by incomprehensible structures. Although the soldiers are still in Roman armour only one of them, the centurian on the right, gives a feeling of Roman antiquity.

As the Ovetari chapel was destroyed by a direct hit in the Second World War, and efforts to piece together the frescoes have had a limited success, it is as well to record what photographs cannot show, the great difference in tone and colour between the two sides. The St James series, which were on the left side, were in a greeny-grey colour, without great felicity of tone. The trial scene, in fact, was so grey as to merit Vasari's criticism of Mantegna, applied, of course, to his later work, that he made his figures look like statues. But this did not apply to the only fresco by Mantegna on the opposite wall, the *Martyrdom of St Christopher* [5], which was away being restored when the chapel was bombed, and so has survived. It appeared, by contrast with the others, to be painted in silvery and pinkish colours, with a delicate sense of tone, and personally I have little doubt that this represents the influence of Piero della Francesca. The other frescoes on the wall, are by two obscure artists, who, much to the annoyance of art-historians, have signed their names, Ansuino da Forli and Bona da Ferrara.[1] They are even more obviously influenced by Piero. This new turn in Mantegna's development was the result of a visit to Ferrara, where Piero had been at work before 1450. Piero has won Mantegna back from illusionist perspective to Brunelleschian perspective

[1] These inconvenient signatures so greatly distressed the most brilliant critic of Italian art of the last 50 years, Roberto Longhi, that he maintained that they were forgeries. They have recently been confirmed by documents.

5 Mantegna, *Martyrdom of St Christopher*, 1454–57

at its most scientific. A copy in the Jacquemart-André Museum, made before the fresco was ruined by damp, shows how it was conceived as one scene, divided, in Piero's manner, with a fluted column, and with a marble inlaid floor.

The influence of Piero had a further interesting result: it led Mantegna away from archaeology. This may in part be due to his realisation that classical figures could not be combined in one consistent whole with Brunelleschian perspective; he may also have reflected that the martyr-dom of St Christopher took place at a later period than that of St James, and in Lycia instead of Rome. He was freed from a too conscientious duty to antiquity. Nonetheless, we may suppose that he had recognised in the works of Piero how contemporary dress and even portraits could be given an ideal character as elevated as that of Roman sculpture. Vasari tells us that the figures are all portraits of Paduan notables, and this interest in individual characters, especially if they are wilful and sharply defined, is also a specifically Roman characteristic in Mantegna, of which the two Roman portrait tombs in the background of the St Christopher are a sort of acknowledgement.

The frescoes in the Ovetari chapel, painted between the ages of seventeen and twenty-five, represent a continual process of self-education; we feel in them some of the excitement of a young man of prodigious gifts finding his way and realising the full extent of his talent. They are followed by a few years of consolidation in which he perfected his highly personal style. I use the words 'consolidate' and 'perfect' advisedly, as they describe the character of his ambitions. He was induced by his love of the antique, no less than by technical virtuosity, to aim at a style which should have the durability and finish of cameo. Not that Mantegna's style was consistenly antique. In the Madonna of the S. Zeno altarpiece the way in which he makes the folds of the drapery follow the figure, outlining every form like a contour map, is more Romanesque than Roman. And although he was capable of realising large plastic units, his

desire for finish led him to a Gothic passion for detail.

The first of these micromaniac works is the predella of the S. Zeno altarpiece, painted about 1458. The altarpiece itself, still in Verona, is a painted version of the sort of work which was being produced in Donatello's workshop, and, although much praised, seems to me without inspiration. The groups of saints on either side of the central panel are conventional and so tiresomely drawn that I incline to think they are largely the work of a pupil. On the other hand, the predella panels are painted with a feeling so intense that to look at them for long and follow every incident leaves one emotionally exhausted. The incredible skill with which every detail is realised, the firmness, certainty and power of subordination to a general form, is all that Dürer, at the same period of his development, attempted, and (in his paintings) never quite achieved. In spite of the Roman soldiers in their armour, it is a great work of Christian art, and shows that a whole essay could be written, as a pendant to this one, on Mantegna as a Christian painter. I will only point out some of the ways in which Mantegna succeeded in combining his sincere Christianity with his other religion, the antique.

The subject in which his two beliefs could be most convincingly united was that of St Sebastian. The saint's body could be a classical nude, his head could express Christian pathos. Mantegna painted the subject three times, and in the first two versions, those in Vienna and in the Louvre [6], he emphasised the classical element by placing the saint in front of an antique column, and strewing on the ground beside him a curious assortment of antique fragments. Yet the *St Sebastian* in the Louvre, by the expression of his head, and the way in which he rises above his brutal executioners, is an embodiment of Christian faith that Mantegna never surpassed. In his last *St Sebastian* [7], now in the Ca' d'Oro, Venice, the classical element has been almost totally rejected. The heavily modelled body is no more than a pretext for the cruel crisscross of the arrows. And in order to make his meaning clear Mantegna has put

6 Mantegna,
Martyrdom of
St Sebastian, 1480

7 Mantegna, *Martyrdom of
St Sebastian*, 1490

beside a guttering candle the inscription *Nihil nisi divinum stabile est, caetra fumus.* The aged Michelangelo might have written the same.

He and Mantegna are the two great pessimists of art. Yet both had a vein of tenderness which appears in their representations of the Virgin. In Mantegna's Madonnas the plastic character of the Madonna's head is entirely Roman, but her tender expression and gesture are Christian. The most moving example is the Simon *Madonna* in the Berlin Gallery [8]. It is one of those pictures on linen where Mantegna has consciously repressed his passion for detail in the interest of the sculptural whole. It used to be supposed that these more largely seen works came late in Mantegna's development, and that in old age his micromania, or at least his inhuman sharpness of eye, deserted him. But this is untrue, as the Simon *Madonna* is quite early, and a very late work, the *Christ supported by two Angels* at Copenhagen, has the most detailed landscape he ever painted. One literally requires a magnifying glass to appreciate it.

How far, as an independent artist, working chiefly on church commissions, Mantegna's dream of Roman magnificence could have developed it is hard to say, but in 1459, after long, patient and strenuous solicitations on the part of Ludovico Gonzaga, he became official artist to the Court of Mantua. Mantegna is the first artist of the Renaissance to be entirely in the service of a humanist prince, and his activities at Mantua were of a kind which was to become familiar. Like Raphael at the Vatican, Inigo Jones at Whitehall or Lebrun at Versailles, he was an artistic factotum. He produced designs for architecture, sculpture, goldsmith work, crystal goblets, tapestry and embroidery. He superintended pageants, and did scenery for Latin plays. And incidentally he did some painting. But above all he was the arbiter of taste to whom was referred any new project or addition to the collection; and this meant that, like Raphael and Inigo Jones, he was to a large extent the intermediary between the native taste and the art of antiquity. As with all court artists, a great part of his production is lost to us—not only the pageants, but the

goblets, embroideries and decorative ornaments. We can probably form some idea of their design from his beautiful engravings of classical subjects—for Mantegna's engravings all seem to reproduce motives which he executed in other materials. With remarkable prescience he foresaw that this might be the only means by which his chief inventions would be known to posterity.

In his two *Battles of Sea Gods* [9] we see with what understanding and vitality he has recreated the motive of an antique frieze, using very un⁄antique foreshortenings, but a severity of style which we think of as classical. His two Bacchanals make a less classical impression because they contain grotesquely flat figures, far outside the antique canon. A drawing in the British Museum of *Mars between Venus and Diana* [10], probably also connected with the decorations of the Palace, shows his paganism, in a less idiosyncratic form. It is a ravishing piece of *quattrocento* art, and the figure on the right has the willowy proportions of the Graces in Botticelli's *Primavera*. The influence of Mantegna on Botticelli is one of the many unexplored areas of his career. He was in Florence in 1466, and it seems incredible that Botticelli did not see drawings like the *Mars, Venus and Diana*, that is to say twenty years before the *Primavera*.

Of the surviving paintings executed for the Gonzagas, a few are official works, and the S. Zeno altarpiece has shown us how dull a painter he could be when his imagination was not touched. But he also painted a number of commissions which were undoubtedly masterpieces. Unfortunately none of the major works he executed in his best Mantuan years has come down to us intact. Of the three that are mentioned in a document of 1492 as being his chief services to the Gonzagas, the decorations in the chapel are lost, and both the Camera Depicta and the *Triumph of Caesar* have suffered at the hands of restorers an obliteration only slightly less severe than that inflicted on the Eremitani by American bombers.

In spite of restoration we are fortunate in having the Camera Depicta,

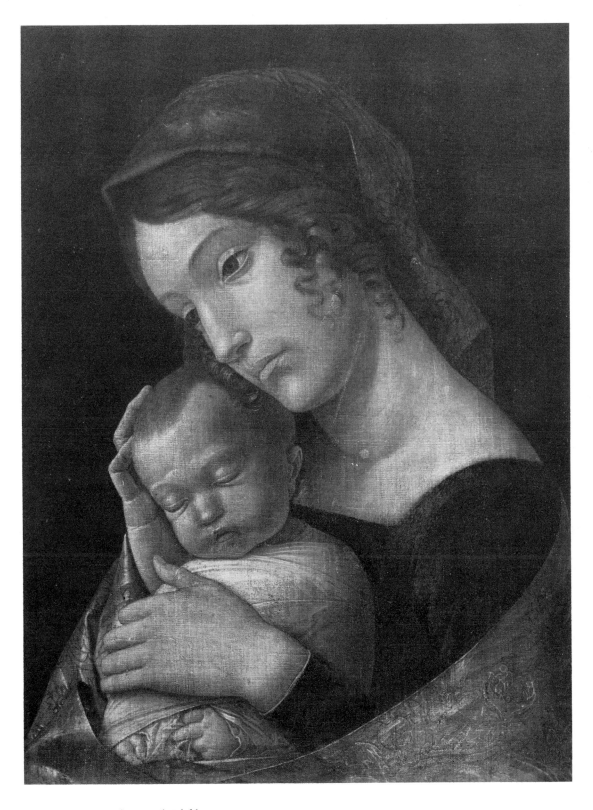

8 Mantegna, *Madonna and Child*, 1475

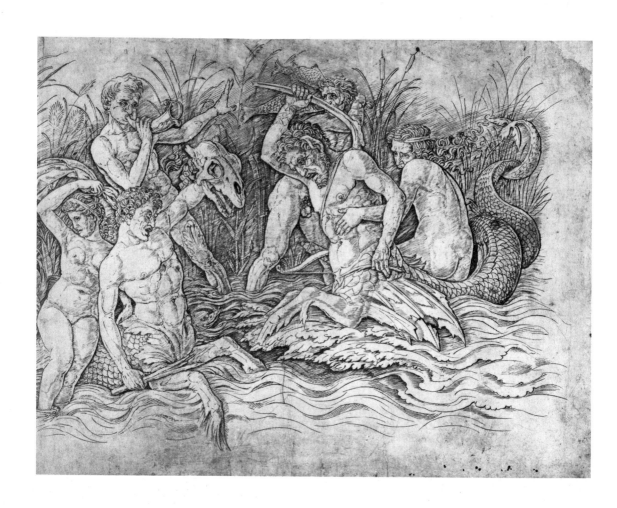

9 After Mantegna, *Battle of the Sea Gods*

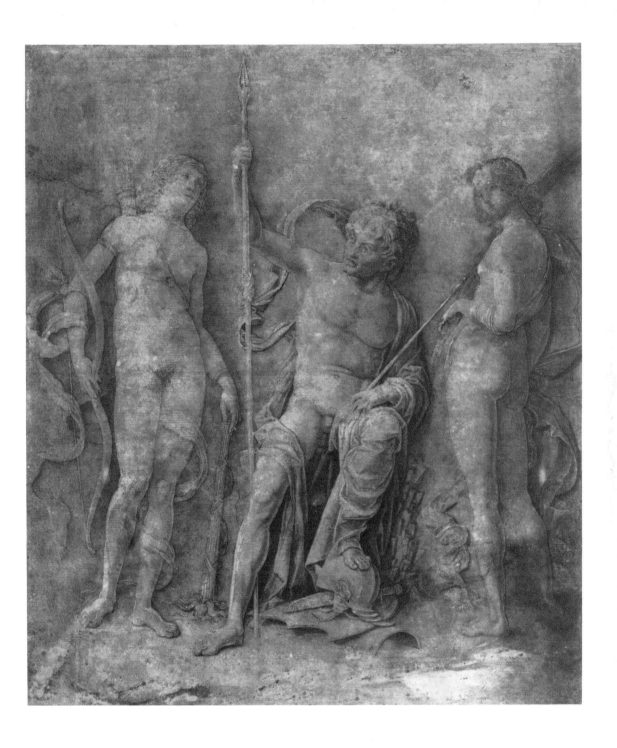

10 Mantegna, *Mars between Venus and Diana*, 1490–1500

known since the sixteenth century as the Camera dei Sposi, as it reveals a side of Mantegna's art of which otherwise we should hardly have been aware, his ability to show actual men and women in relationship with one another. Perhaps he was influenced by Masaccio's *Sagra* in the Carmine, which he would certainly have seen when he was in Florence in 1466, and which was the first painting to show real people in natural surroundings. But one can hardly believe that Masaccio would have equalled, or desired to equal, Mantegna's skill as a portrait painter. The room is designed as an open colonnade. Life-size figures are standing on the platforms in between the columns, and over the mantelpiece the principal group of the Marquis, his wife and secretary, is raised as on a dais [11]. Everything is done from the single perspective point of view of a person standing in the middle of the room, so that the figures on the dais are slightly foreshortened. Apart from the technical virtuosity involved, every painter knows how exceedingly difficult it is to bring off a life-size group of this kind, where the conflicting interests of likeness and anim-ation are all a menace to unity of style. It is a measure of Mantegna's success that his Gonzaga family immediately reminds us of two of the greatest family groups in subsequent painting: Titian's *Paul III and his nephews*, and Velasquez's *Las Meninas*. Perhaps it is only the coincidence of the dwarf and the dog, but I cannot help thinking that Velasquez, who had certainly been to Mantua, had this group in mind when he first visualised his masterpiece.

Old photographs show that one of the chief results of restoration has been to deprive this group of its atmospheric quality. Of this a little more can be seen in the better preserved fresco of the meeting between the Marquis and his son, the Cardinal Francesco, whose recent elevation was probably the occasion of the rooms being painted [12]. The contrast between the grave and sensitive head of the Marquis, whose treatment of Mantegna was a model of tact and tolerance, and the somewhat operatic figure of the Cardinal, who had struck up a friendship with Mantegna,

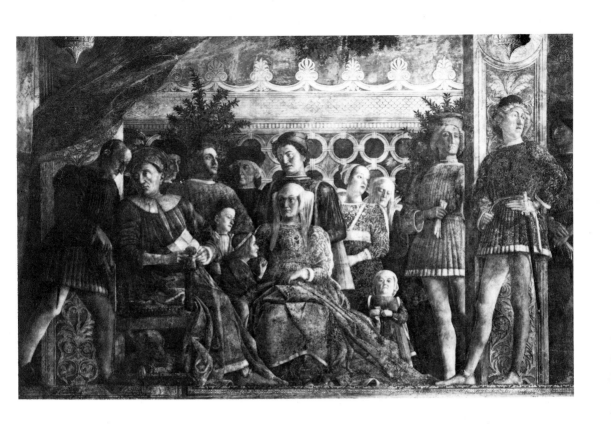

11 Mantegna, *Ludovico Gonzaga, His Family and Court*, completed 1474

shows his unexpected sense of human relationships. His father raises his hand in a gesture which is more one of astonishment than congratulation. The new Cardinal is perfectly complacent.

The crowning feat of illusionist logic is the hole in the ceiling. It is the end of those experiments in perspective which began with the *St James led to Execution*, and it is the beginning of that road which was to lead via Correggio to S. Ignazio and the Gesù. Once more we cannot say how far the effect has been ruined by repainting; but, making all allowances, we may agree that this crowning feat of illusionist perspective was funda-mentally out of keeping with the *quattrocento* style. These rigidly fore-shortened cherubs are slightly ridiculous because they are solid, self-contained, intellectually conceived units. Whereas the only way in which to make this illusion acceptable would have been to use forms which flow or melt into each other, so that we are swept off our feet before we can ask too many questions.

The least damaged part of the ceiling is the *grisaille* decoration with scenes from Greek mythology in the spandrels and busts of Roman emperors in the *oeils-de-boeufs* [13]. The busts are certainly the most correct and convincing sham antique works which had yet been pro-duced in the Renaissance, and if we were shown a photograph of one of them out of its context we should probably date it in the sixteenth century, not in the year 1473. Mantegna has made the ideal heads so human that they do not conflict with the portrait heads below. Between the busts are lunettes with scenes from the legends of Orpheus and Hercules. With one exception they seem to have been very little restored, and are painted with a freedom and energy that we do not always associate with Mantegna. In spite of their antique subjects they do not seem to derive from classical motives. They make us realise what we have lost by the destruction of the other frescoes in the Palace.

The ceiling of the Camera Depicta is an imaginative reconstruction of what, in an age of civilised human greatness, a prince ought to have over

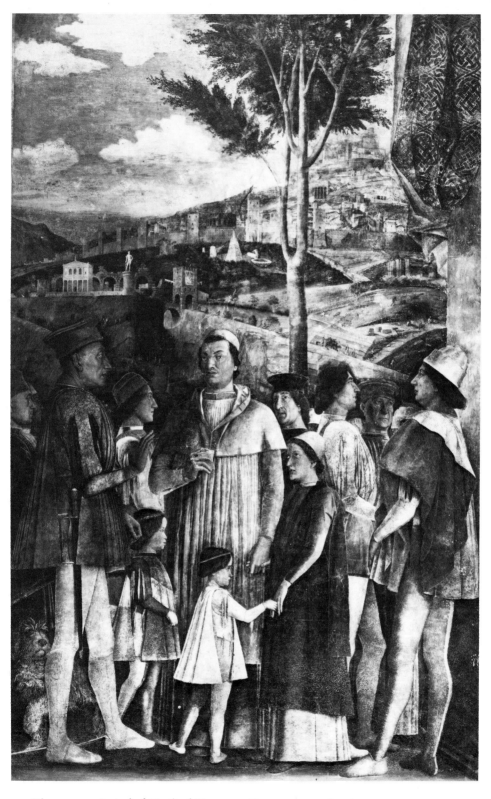

12 Mantegna, *Arrival of Cardinal Francesco Gonzaga*, completed 1474

his head. Now that the Palace of Mantua has been restored with great intelligence and learning, it is clear that Mantegna's style dominated the decorative scheme of the whole building even more than that of Piero della Francesca dominated the Palace of Urbino. Until the time of Versailles the Palace of Mantua was the model for the European ruler, a sort of architectural counterpart to Castiglione's *Cortegiano*. Certain of its features, for example the gallery for the display of antiquities, survived as a necessary feature in a great house right up to the nineteenth century. Perhaps few dreams have been as extravagantly influential as Mantegna's dream of Roman grandeur.

During the forty years of his employment at Mantua, Mantegna's knowledge of antique art increased enormously and we have many testimonies to his mastery of the subject, none more striking than that his conversation about antiques prevented Cardinal Francesco Gonzaga from going to sleep in his bath when he was taking a cure at Poletta in 1472. From having had to reconstruct antiquity out of the few fragments available in Padua, he was now free to travel and inspect every antique monument above ground. The account of one of his archaeological expeditions has survived, written as an appendix to the life of the first great antiquarian traveller, Cyriac of Ancona, by the humanist, Feliciano.

On 23rd September, 1464, Mantegna and his friends set off by boat to explore the shores of the Lake of Garda, in search of ancient monuments and unknown inscriptions. One of their number, Samuele da Tradate, was proclaimed Emperor of the Society; Mantegna and Marcanova were 'Consuls'. They crossed the lake—the field of Neptune—in richly adorned boats, the Emperor crowned with laurel and ivy, playing the zither and rejoicing. Having reached the other side they gave thanks to the Thunderer and his Glorious Mother for their safe journey, and for having opened their hearts to enjoy such venerable remains of antiquity. They then made a rich haul of inscriptions, which were duly copied. No

13 Mantegna, *Ceiling decoration with bust of the Emperor Tiberius*, 1473

wonder the whole account is headed '*Jubilatio*'. There have been many
productive archaeological picnics since; Poussin's expeditions into the
Campagna, the builders of Stowe discussing their temples, the Camden
Society criticising severely the Angel Choir in Lincoln, and in each of
them we see how a dream of the past may become an incentive to creation
more powerful than any experience of contemporary life. But never,
perhaps, has the past appeared in fresher and more splendid colours than
to the antiquarians of the fifteenth century. For one thing it has been
gradually overlaid with erudition, which, like discoloured varnish, has
made it acceptable to academics. In the fifteenth century a discovery *was* a
discovery, contributing a missing piece to a puzzle of which the whole
picture was still unknown. But, more important, the glory and the
freshness of the dream depend on our believing that these fragments reveal
to us not only the art of a past age, but also a philosophy and a way of life
which is vitally necessary to us. The volume which contained the first
critical evaluation of the Elgin marbles, also included the first publication
of Keats's *Ode to a Grecian Urn*. The discoverers of Gothic art, Pugin and
Ruskin, were the prophets of medieval religion and society. And so
Mantegna, in his archaeological expeditions, was no mere dilettante, but
was searching for visual evidence that life had once been lived on the
heroic plane.

Here we reach one of the great barriers to our appreciation of his art;
for we have learnt to view with mistrust, and even with horror, much of
what seemed most admirable to him in the Roman ethos. The triumph-
ant power, the humourless authority, the relentless will of Rome, have
been put before us in a corrupted form, and we have grown to believe that
this corruption is an inevitable consequence of their fulfilment. Ours is
the Rome of *I Claudius*. Mantegna, though familiar with the spectacle of
tyrants, had no such qualms. To him Roman grandeur was one with
Roman *gravitas*, Roman triumph with Roman justice. And it was for
this ideal that he designed the decorations now at Hampton Court.

The *Triumph of Caesar* [14] seems to have been begun by Mantegna shortly before the death of his devoted patron, Duke Ludovico, in 1478, and was far enough advanced by 1486 to be shown to a distinguished visitor to Mantua. The work was interrupted for eighteen months by Mantegna's visit to Rome 1488–1490. It is often said that he was influenced by the reliefs of the Arch of Titus, but it seems unlikely that he made many changes in the compositions after 1490.

The nine large canvasses were hung in various places, but it seems probable that they were first intended as decorations for a theatre, for which Mantegna also designed the allegorical triumphs of Petrarch. In this theatre were performed the comedies of Plautus and Terence, and it was there that the *Orfeo* of Poliziano, written to amuse the Cardinal Francesco during his cure, received its first performance, under Mantegna's direction. We in England are reminded of Ben Jonson's learned Masques for Charles I, with scenery by Inigo Jones, and it is a nice example of historic justice that Mantegna's *Triumphs* should, in fact, have been bought by Charles I on Inigo Jones's advice.

I have said that all Mantegna's major works have been brought to ruin, and the *Triumph of Caesar* is no exception. The canvasses were completely repainted by Laguerre in the late seventeenth century, and many subsequent attempts to restore them have only made matters worse by depriving them of such consistency of style as Laguerre's classicism may have given them. A section was in fact repainted by Paul Nash, under the direction of Roger Fry, and it had a flavour of the 1920s almost as strong as *The Boy Friend*. In only a very few details can one divine some of the style of the original, and we recognise that even in this period of evolved classicism Mantegna's drawing still had a sharp, springy, *quattrocento* quality. His archaeological dream had not smothered the vital consistency of his style—a fact which would have made all the difference to our appreciation of the *Triumphs*.

In the 1930s the Surveyor of the King's Pictures, Collins Baker, who

was in charge of Hampton Court, entrusted the care of the *Triumphs* to a so-called restorer named Kennedy North. He cleaned them drastically and filled in the empty spaces with his own inventions. They seemed to have been ruined. But later an expert restorer named Brealey took charge of the long-suffering canvasses once more and discovered a good deal more of the original painting than would have seemed possible.

Fortunately for us all, old pictures are very tough. As a result the Mantegna *Triumphs* make a decorous impression, without, of course, any of the brilliance that was thought to be their chief attribute. They were intended as decorations, and, whether in a theatre or in an open court-yard, they were thought to be bright and splendid. Almost our only indication of this is to be found in the trophies and banners, which, although reduced to silhouette, still maintain their decorative intention. As for their significance, it is difficult for us to realise how impressive must have been their antique character. They are certainly the nearest thing in painting to the Latin poetry which, from Petrarch's *Africa* onwards, absorbed, and, we may think, deflected so much of the literary talent of the time. As the equivalent of a Latin metre, Mantegna has returned to the frieze-like treatment of his Roman frescoes in the Eremitani. But this time he has taken a vanishing point only a little below the picture frame, so that the foreshortenings are less obvious, and, although he has used an illusionist perspective, he has avoided anything which would give the violent impact of the buildings in the earlier fresco. As a result, the frieze-like effect is far closer to the antique, and is enhanced by the silhouettes of Roman accoutrements which fill the upper half of the canvasses. In these we see the fruits of Mantegna's archaeological expeditions. I do not know how far these standards, tubas, battering-rams and trophies are all accurate, but at least they still make a convincing impression after our four centuries of archaeology.

Even more remarkable than the detail is the classical sense of design which Mantegna has achieved, and here again we ask what models he

14 Mantegna, *The Triumph of Caesar: The Corselet Bearers*, c. 1486–94

can have had to guide him. His imagination was steeped in Appian's account of the Triumph of Scipio, and Suetonius's *Triumph of Caesar*; and no doubt he had been collecting material for the subject for years. He may even have organised pageants in this form, for triumphal processions *al' antica* were frequent in the Renaissance. But of actual reliefs on this scale he can have known little.

The series was begun before his journey to Rome, and while he was there Mantegna, in his numerous letters to Francesco Gonzaga, never mentions the ruins of antiquity. We cannot doubt that he was much impressed by the two famous reliefs on the Arch of Titus, then much less damaged, which must have made rather the same effect from below as indicated in Mantegna's perspective. But by the 1480s Mantegna's sense of composition must have been complete, and the sight of reliefs in Rome is not likely to have influenced him. Of course he may have paid some unrecorded journey to Rome at a much earlier date. Artists move about more often than scholars are prepared to admit, and a visit to Rome in the 1450s, or even later, would make Mantegna's development easier to understand.

The Triumphs seem to have been finished by 1494. They represent the high point of Mantegna's humanism. Thenceforward he painted certain pictures with classical subjects, and exerted his classicising influence on the minor arts: but he did not again attempt an heroic vision of antiquity. The pagan pictures he designed for Isabella d'Este's studiolo were learned dilettantism as was appropriate to their owner. In the *Parnassus* there is beauty of line and movement, and a poetry more *quattrocento* than antique: but the serious, ethical quality of the earlier works is abandoned, and recent scholars have gone so far as to regard the whole as a sort of satire on antiquity—an anticipation of Ariosto. The *Parnassus* is a charming picture: its companion piece, *Minerva expelling the Vices from the Grove of Virtue*, is ugly and confusing, and shows us why artists made any excuse not to work for the dictatorial blue-stocking.

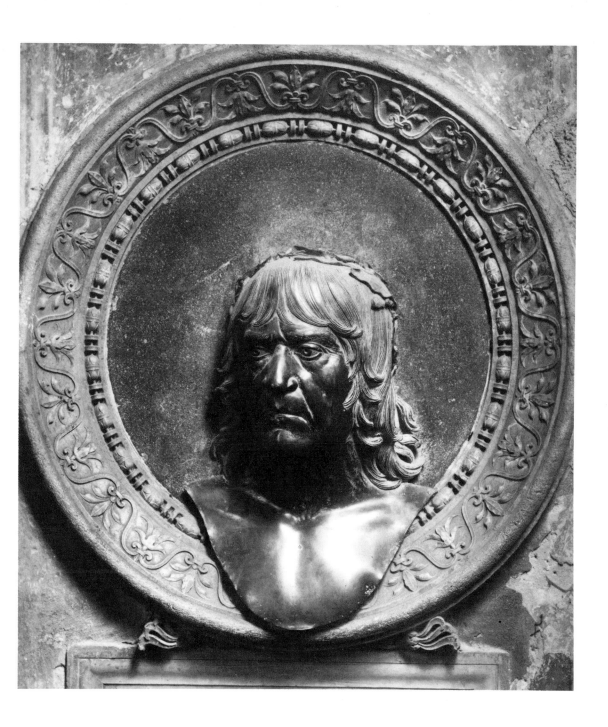

15 Mantegna, *Self-Portrait Bust*, 1480–90

Mantegna had always been a wilful and uncompromising character, and in later life his devotion to the ideals of republican Rome produced one of the most formidable faces in the whole of Renaissance portraiture [15].[1] These are not the features of one who is prepared to make, or become, a salon ornament. And in fact Mantegna's later paintings are extremely austere. They are chiefly in monochrome and on canvas, as if the old virtuoso derived a grim satisfaction at refusing to allow his patrons the jewel-like richness for which he was famous.

Mantegna would direct our minds solely to nobility of form and gravity of sentiment; and we may admit that the relentless way in which every shape is hammered out in conformity with a single idea is extremely impressive. But they have the defects of all great art of renunciation, from *Paradise Regained* downwards. Unlike Milton, Mantegna never rejected antiquity, perhaps because he was a Roman, rather than a Pagan. The stoic discipline, which was the basis of Roman ethics, had after all played a large part in the formation of Christianity. But in his later work the classical subjects become more poignant and personal, culminating in that haunting masterpiece *The Dead Christ* in the Brera, and we see that in the end Mantegna has found in Christianity a feeling of ultimate values which Rome, even the grave and magnificent Rome of his imagination, could not give him.[2]

[1] The author of this magnificent bust is unknown, and I cannot resist the belief that it was Mantegna himself. It stands over his tomb in S. Andrea, Mantua, and portrays a stern and powerfully intellectual man. We are more than ever impressed by the tolerance of the Gonzaga family.

[2] This essay is based on a lecture given at the Royal Society of Arts, 1958.

BOTTICELLI'S ILLUSTRATIONS TO DANTE

'The greatest artist of linear design that Europe ever had.' These words, written by Bernard Berenson in about 1892, and printed in the most influential of all his books, the *Florentine Painters*, express the feelings that all educated people had had about Botticelli in the preceding twenty years. Towards the end of the century Berenson repeated the same opinion, with certain reservations, in his great book on Florentine drawings. 'The value of these drawings consists in their being the handiwork of one of the greatest masters of the single line which our modern western world has ever had.'

The average art lover must find it hard to believe that there are ninety-three authentic drawings by Botticelli which practically no one has ever seen. But how many have seen Botticelli's illustrations to Dante in the original? Many will of course have seen reproductions of some of the most famous, like *Purgatorio XXVIII* or *Paradiso I*. But nearly all these reproductions were not made from original photographs, but from the gigantic plates of Lippmann's original publication of 1887, and these were done in gravure, which has deadened the variations in the quality and emphasis of line. I will speak later of the exceptional difficulties in reproducing the drawings.

What accounts for this curious indifference to what should, after all, be one of the great treasures of European art? Partly the accidental fact that

since the war the drawings have been in East Berlin (actually about a third of them are on loan in Dahlem). But another reason is that Botticelli is no longer a name to conjure with.

One should become reconciled, as one grows older, to changes of fashion in the arts. After all, one accepts, and sometimes welcomes, changes of taste in dress. But I confess that I find the rise and fall of a great artist's fashionable reputation depressing. The rise of Botticelli's fame dates from 1870, when Walter Pater published an essay which was to act like an elixir on the young aesthetes of the time. Pater himself would have shrunk from this claim, and in the opening sentences went out of his way to disavow it, saying, 'people have begun to find out the charm of Botticelli's work, and his name, little known in the last century, is quietly becoming important'. The only written proof of this 'quiet' emergence is an article by Swinburne, not normally a quiet man, published in the *Fortnightly Review* for July 1868, in which he speaks of 'the faint and almost painful grace that gives a curious charm to all the works of Botticelli'. I fancy that anyone who knows the period will agree that it was probably Rossetti who 'discovered' him.

Pater, with his astonishing clairvoyance, immediately associated Botticelli with Dante, on the basis of the slenderest hints in Vasari. If only he had seen the 76 drawings then lying perfectly unknown in Hamilton Palace! But then he may not even have seen the *Primavera*. It was his sublime description of the *Birth of Venus* that opened the eyes of those who cared for art to a unique imaginative experience.

After his prose poem is over, this shy recluse suddenly takes fright and ends with a disparaging paragraph. 'But, after all, ... is a painter like Botticelli, a secondary painter, a proper subject for general criticism?' No such doubts restrained John Ruskin when, two years later, he made the same discovery. He describes how, in front of the *Coronation of the Virgin*, he was in an ecstasy, which he had not felt since he lay on the floor of S. Rocco at the sight of Tintoretto's *Crucifixion*. He admits that he had not

recognised the greatness of Botticelli till 1872. But then immediately Botticelli became 'the only painter of all the religious schools who unites every spiritual power and knowledge'.

No wonder that earnest lovers of art were carried away. I remember Sir Edmund Gosse, for many years the undisputed leader of English literary life, saying to me, "the name of Botticelli was the key to the most select society in England". He admitted that he had not seen many of Botticelli's pictures, but he was not the man to neglect a key. I am afraid it would not open many doors today; and we may allow that few tides of taste can have been more certain to withdraw. Botticelli has not exactly gone out of fashion; he has just passed into the limbo of reaction. It is not mediocrities who pass in and out of fashion; it is the very greatest artists, and that is why I find these reactions depressing. That sensitive people can cut themselves off from the life-giving, the exalting experience of communion with a Raphael or a Botticelli is like some betrayal of our belief in greatness. When they look at the details of the *Spring* or the *Venus* their hearts must beat faster. But Botticelli is no longer the subject of passionate conversation, as he was in the last twenty-years of the nineteenth century. Thus we should remind ourselves of one of his most extraordinary achievements, in which this exquisitely serious artist sets himself to interpret the work of the greatest philosophic poet of all time.

Now let me 'sweep the dust before the door'. The drawings were done for Botticelli's patron, Lorenzo di Pier Francesco de' Medici, cousin of the great Lorenzo and often referred to as Lorenzino. Lorenzino, who had commissioned both the *Primavera* and the *Birth of Venus*, was a more enlightened patron of visual art than his cousin, whose chief interests were in literature. We have a curious piece of evidence that as late as 1496 Lorenzino was on very close terms with Botticelli, and used him as an intermediary in a correspondence with Michelangelo in Rome. The Dante drawings were recorded by the earliest collector of information about Florentine art, the so-called Anonimo Gaddiano.

Dante in carta pecore, che fu tenuto cosa meravigliosa. Vasari's account of
the matter, written about 40 years later, is more complicated. 'He made a
commentary on part of Dante, illustrated the Inferno, and printed it; in
which he wasted much of his time, bringing infinite disorder into his life
by neglecting his work. He also printed many of the drawings that he had
made, but in a bad manner, for the engraving was poorly done.' No
mention of *carta pecora*, nor of the fact that Botticelli (or a scribe) had
written the relevant canto on the back of each drawing, all of which
suggests that Vasari had not seen the originals. But, as usual with Vasari,
a few errors are accompanied by valuable information. Botticelli did in
fact do drawings for an edition of Dante that was engraved by Bandini
and printed in an edition of 1481 [1]; and Vasari was right: the engrav-
ing is poorly done. Each is inevitably related to the drawings in *carta
pecora*. But one need only compare it with the drawing of the same subject
to see how greatly Botticelli had enlarged his range. These engravings
were printed on thin paper and stuck into the book, occasionally (as in
the Bodleian copy) stuck in upside down, which suggests undue haste.

Vasari tells us that Botticelli made a commentary on Dante. This
seems improbable, but it is true that he was acquainted with the two chief
Dante commentators of the time, Manetti and Landino, and may have
discussed interpretations with them. It is quite probable that the study of
Dante led him to neglect his work, which is something that can happen
to any of us who embark on that limitless sea; and no doubt the vast
undertaking of the 85 drawings (originally over a hundred, for ten from
the Inferno and four from the Paradiso are missing) must have kept him
from other commissions.

From Vasari's time onwards we hear nothing of the drawings until
eight of them were bought by Queen Christina of Sweden, who be-
queathed them, with the rest of her collection, to the Vatican. The
remaining 76 were in the hands of an Italian bookseller in Paris named
Claudio Molini, and it was he who sold them to that collector of genius,

1 Bandini after Botticelli, *Inferno XIX: The Simonists*, 1481

William Beckford. Beckford's library passed to his daughter, who became Duchess of Hamilton. The indefatigable Dr Waagen, in his *Art Treasures of Great Britain*, published in 1854, noted a book of drawings, adding that the hand of Sandro Botticelli is very obvious. Milanesi does not mention Waagen's discovery in his edition of Vasari. But somebody had noticed it. This was Dr Lippmann, the creator of the Berlin *Kupferstichkabinet*. When the drawings were put up for sale in 1882, he came to London, stopped the sale, and bought the 85 drawings for his department. Shortly afterwards, Joseph Strzygowski, of all unlikely people, identified eight drawings in the Vatican that had belonged to Queen Christina, as being part of the same series.

The whole 85 were published together in what must be one of the most unwieldy volumes in existence (for the drawings, which measure $12\frac{1}{2}$ inches by $18\frac{1}{2}$ inches, are reproduced full size, with ample margins). But Lippmann's text has never been surpassed, and, as I have said, his plates have been the source of all subsequent reproductions of the drawings.

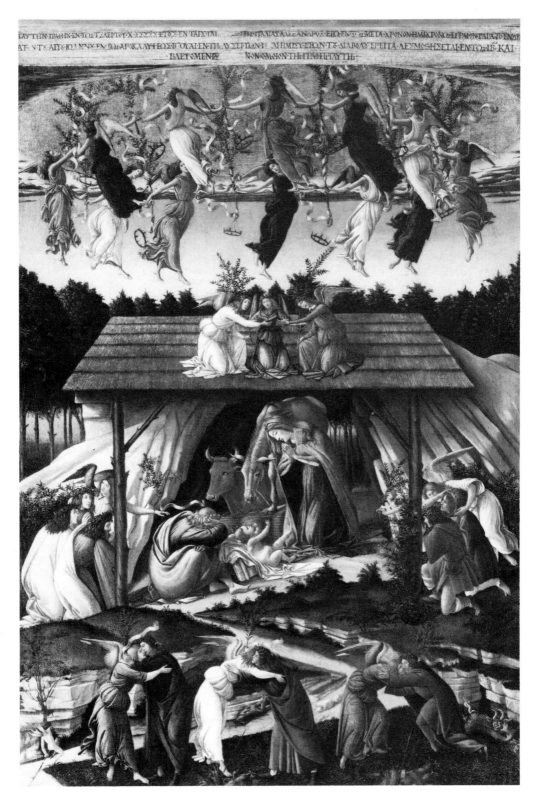

2 Botticelli, *Adoration of the Shepherds (Mystic Nativity)*, 1501

When were the drawings done? Berenson says, 'not before 1500'. This is much too late, on every ground. Stylistically the drawings cannot be in any way related to Botticelli's latest works. The abrupt, angular movements of the S. Zenobius panels are at the furthest remove from the sweet, flowing movements of the Dante drawings. We have a legitimate standard of comparison, the angels in Botticelli's *Adoration of the Shepherds* [2] in the London National Gallery, dated the 20th day of March 1500 (which means, in our style, 1501). These thin, scrawny, unseductive creatures, spiritually beautiful as they are, bear no resemblance to the angels with their billowing drapery, dancing on air, who surround Dante and Beatrice in *Paradiso XXVIII* [3, page 158]—which one might suppose to be one of the latest of the illustrations. The last time we find this kind of drapery, and this pleasure in physical beauty, is in the small tondo in the Ambrosiana [4]. The painting most often spoken of in relation to the Dante drawings is the *Calumny of Apelles*. It is usually dated too late. In addition to the draperies, the heads of the girls have a round sweetness entirely different from the quasihysterical profiles of the post1500 pictures. As I have said, the drawings show a great advance in imaginative sweep to the engravings of 1481. It seems reasonable to suppose that this immense task dated from after the death of Lorenzo (1492), after which Botticelli worked almost entirely for his friend Lorenzino. They cannot possibly be later than 1497, when Lorenzino was forced to leave Florence, and when Botticelli himself had thrown in his lot with Lorenzino's enemies, the followers of Savanarola. Indeed I think one can safely give this date as the point at which his style suffered its catastrophic change.

Very soon after the first appearance of the *Divine Comedy*, it began to be illustrated. This was inevitable. Apart from its obvious greatness and authority, which was never in doubt, the *Comedy* was full of descriptions so vivid, concrete and convincing that readers longed to have them made visible. Various critics have written of Dante's visual images, and a good,

short, question-raising article on the subject was one of Berenson's earliest pieces of writing. But if one uses the term visual imagery in the sense that Keats uses the words, then it is extremely doubtful if the term applies. The most vivid and beautiful images in the *Comedy* are to be found in the similes, and they are drawn directly from observation of nature. I am sure that Dante never conceived that they could be reproduced visually; and they weren't, even by Botticelli. The descriptions of action were a different matter, especially in the *Inferno*, in which Dante had around him models in the familiar subject of the Last Judgement. In fact he would have seen Giotto's *Last Judgement* in the Arena chapel in Padua which was painted almost at the same time. But when fourteenth-century illustrators set to work on the *Divine Comedy* they found themselves in a world of images far beyond their powers. The illustrator of a codex in the Marciana, who is singled out by Berenson, gives a very staid and (if I may use the word) bourgeois visual commentary on the *Divine Comedy*.

In general the style of the time did not allow for a depiction of the body in movement in the way that most of the terrible activities of the damned demanded. For this reason the fourteenth-century illustrators could not deal with the teeming images, poetic, dramatic and often revolting, that succeed each other so rapidly in the *Inferno*. It is usually said that the finest of these manuscripts is in the library of Chantilly [5]. The artist is delicate and scrupulous, but how little his dignified figures convey the appalling incidents of the *Inferno*. He is at his best when Dante and Virgil pay homage to Beatrice, or confront the virtuous pagans. Personally I believe that a manuscript in the British Library is aesthetically (and how hollow that word sounds) equal to the Chantilly manuscript. It is almost as refined, and much more dramatic. Virgil and Dante remain static, dignified forms. The compositions are stiffly parallel with the picture plane, but at least they express some concern at the terrible incidents that they witness, and many of them are illustrated with a scrupulous regard for the text [7]. Here is Geryon [6], who pollutes the whole world, and

4 Botticelli, *Virgin and Child with Angels*, 1490–95

yet Virgil and Dante allow him to give them a lift. Well, we shall see him again in Botticelli's series.

The British Library manuscript is, to my mind, much the most impressive illuminated manuscript of Dante done within living memory of the poet, and in one instance I think that the illustrator of this manu-script excels Botticelli himself. This is in the scene of the encounter with the giants (*Inferno XXXI*) [8]. The Botticelli drawing, with its Pollaiuoloesque figure, is indeed a masterpiece; but when one comes to the end of the canto, where Antaeus gently lifts the two pilgrims to take them down to Cocytus—*Come albero in nave si levo*—like putting a mast on to a ship, I think one can agree that the fourteenth-century illustrator has drawn closer to Dante's idea.

The underplaying (if I may be forgiven such an expression) of Dante's descriptions continued into the fifteenth century, and reaches a climax in the most worked-upon illuminated manuscript of the *Divine Comedy*, illustrated by Guglielmo Giraldi for the library of Urbino only about fifteen years before the presumed date of Botticelli's illustrations. Could anything more un-Dantesque he imagined? Virgil and Dante approach the entrance to Dis like a sacristan and a pew-opener walking through an overcrowded cemetery (*Inferno IX*) [9].

In spite of their reluctance to depict the horrors of the *Inferno*, and the scarcely diminished discomforts of three-quarters of the *Purgatorio*, the early illustrators, with two exceptions, turned more readily to those books of the *Divine Comedy* than to the heavenly visions of the *Paradiso*. They seemed to offer more graphic material. One of these exceptions is the artist whose line drawings flow round the margins of a MS in the Vatican. They were probably done in the last decade of the fourteenth century and they show that the imagery and style of the late *trecento* was not altogether incapable of heavenly grace.

The other exception is, of course, the famous Yates Thompson MS in the British Library, with which some of you will be familiar, as it was

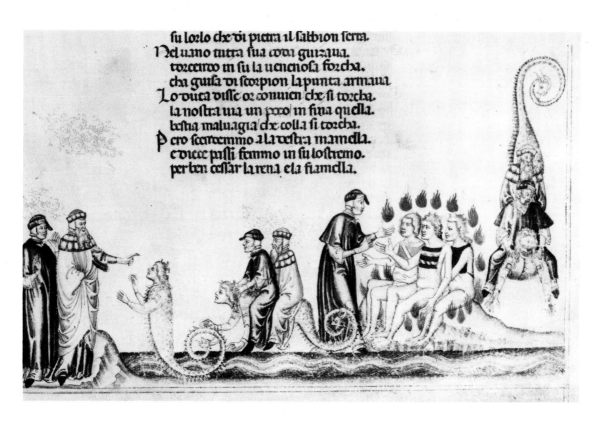

su lozlo che di pietra il sabbion serra.
Nel uano tutta sua coda guizaua.
tozceuro in su la uenenosa forcha.
cha guisa di scorpion la punta armaua.
Lo duca disse or conuien che si torcha.
la nostra uia un pocol in fina quella.
bestia maluagia che colla si torcha.
Pero scendemmo a la destra mamella.
e diece passi femmo in su lostremo.
per ben cessar la rena e la fiamella.

5 Chantilly manuscript, *Inferno XV: The Circle of the Sodomites*, 14th century
6 *Inferno XVII: Dante and Virgil with Geryon*, 14th century

7 *Inferno XXII: Dante and Virgil with Ciampolo*, 14th century
8 *Inferno XXXI: Dante and Virgil with Antaeus*, 14th century

published in a most scholarly manner (but in black and white) by John Pope-Hennessy as long ago as 1947. It is unquestionably the most beautiful illustrated M S of Dante in existence. The *Inferno* and *Purgatorio* are by a Sienese artist, perhaps Vecchietta (at all events, too good for Priamo della Quercia) [10]. The portion illustrating the *Paradiso* is largely the work of Giovanni di Paolo, and is a most imaginative attempt to find concrete analogies to abstract propositions. It can be dated about 1440, that is to say about fifty years before Botticelli's drawings, and has no relation to them at all. The most surprising thing about the *Paradiso* miniatures is their ravishingly beautiful colour, more delicate and bril- liant than almost anything in Giovanni di Paolo's paintings [11].

Having now given a short summary of Botticelli's visual antecedents, let me give some indication of the spirit in which he approached his task. As I have said, he was on close terms with one of the leading Dante commentators of his time, Manetti, and a scrupulous follower of the other, Landino. Landino was the undisputed king of Dante scholars, and it was for his edition of the *Commedia* that Botticelli did the drawings which were so coarsely engraved by Bandini. Landino's commentary is not easy reading, and I will confess that I have not compared it at every point with Botticelli's drawings; but in so far as I have done so I have no doubt that Botticelli followed his interpretations in the *Inferno* as, indeed, Giovanni di Paolo had done in the *Paradiso*. The obvious thing to say is that Botticelli's delicate, fluttering line is not appropriate to the stern punishments of the *Inferno*. Feminine grace, the critics say, as opposed to masculine severity. It is true that Signorelli's roundels in Orvieto, ill- ustrating scenes from the *Purgatorio*, done in the same decade as Botticelli's drawings, have a virile harshness that is outside Botticelli's range: also, I may add, a certain coarseness of execution that mars so much of Signorelli's great fresco. To form a just idea of how Signorelli could have treated scenes of diabolical violence one must turn to his magnificent drawings. The comparison is incomplete, because only eight or ten of the

9 Guglielmo Giraldi, *Inferno IX: Virgil and Dante approach Dis*, c. 1480

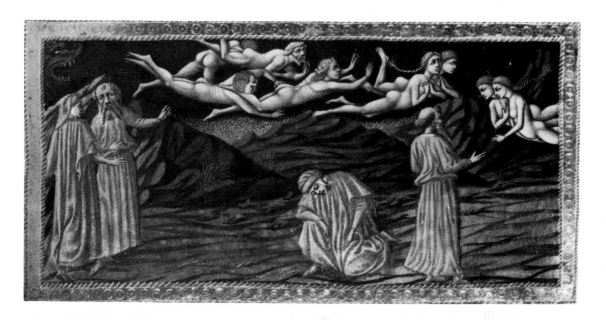

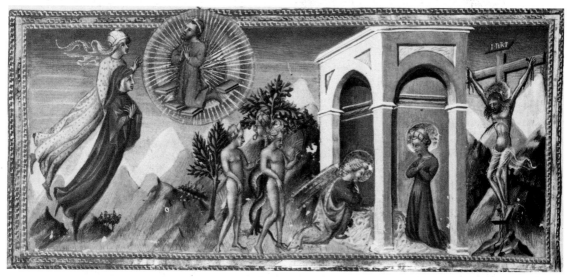

10 Vecchietta? *Inferno V: Paolo and Francesca, c.* 1440
11 Giovanni di Paolo, *Paradiso VII: Beatrice and Dante hover before Justinian, c.* 1440

grisaille roundels are of Dantesque subjects, as opposed to Botticelli's 85.

But the fact remains that there is in Botticelli's illustrations to the horrors of the *Inferno* a conflict between style and content that is rather disconcerting. I have said that the fourteenth-century illuminators tended to omit the more blood-curdling episodes, or put them in an uncomfortable heap in the corner of their illustrations. Botticelli is far too serious a student of Dante to practise such an evasion. There they all are: the Hypocrites nailed to the ground but watched over by a 'painted people', ('they had cloaks on', says Dante, 'with deep hoods over their eyes, such as they make for the monks of Cologne'); the thieves attacked by a kind of serpent called Parcae; the traitors writhing on the ground; and of course the terrible Simonists [12], their heads buried in the earth, flames burning their feet—an image so striking that it appears in many of the fourteenth-century MSS and was the subject of Bandini's engraving. We see how revolting the punishments of hell were supposed to be, and indeed *had* to be if they were to deter aggressive man from making a hell upon earth. These simple lines describe the tortures of the damned with a clarity that is much more disturbing than the more obviously dramatic versions of Zuccaro (and Zuccaro's Dante is very good), simply because it is presented without any apparent emotion.

There are some beautiful drawings in the *Inferno*; for example Canto XVII [13], Geryon, whom we have already met, the savage beast that pollutes the whole world, and yet, as Dante says (what a subtle observation!), 'his face is the face of a just man, the rest of him a reptile's body'. But I think that Botticelli breathes more freely when he reaches the *Purgatorio*. Even in scenes of misery, like this of the envious, the figures are drawn with more human sympathy.

One of the aesthetic advantages of the *Purgatorio* for Botticelli was that it allowed for the appearance of angels. We all know that angels are sexless, and to refer to them as women is a heresy. However, the fact remains that Botticelli loved painting women. Femininity, as his first

admirers recognised, was the inspiration of all his finest work. Suddenly we realise that there are no women in the *Inferno*. (The drawing for Canto V, which could have included Francesca, is missing.) A man's world. But in Canto IX of the *Purgatorio* [14], when an eagle lifts Dante up to the topmost ledge of Purgatory, he is received by an angel who is unquestionably feminine; and thenceforward such angelic types appear more frequently. There they are in Canto XII of the *Purgatorio*, welcoming Virgil and Dante after they have witnessed the punishment of the proud, including the fall of a diminutive Tower of Babel.

I must not skip the illustration to Canto X, which is one of the strangest of the whole series, where Virgil and Dante, after mounting from one side of a steep incline which turns from one direction to another like a wave, '*che si moveva d'una parte e d'altra parte, si come l'onda che fugge e s'appressa*', find themselves in front of carvings which represent allegories of humility. First, and understandably, the Annunciation; then, more unexpectedly, David dancing before the Ark. Alas, the metal point line of the Ark and of David's palace has almost vanished, but one can still make out the figure of David's wife, Michal, mocking him. Finally, Virgil points out to him a huge representation of the *Justice of Trajan* (Trajan plays a prominent role in the *Divine Comedy*) [15], which is so full and elaborate that it must be examined in detail. It is, in effect, a battle scene, reminding one of Raphael's *Attila* in the Stanze; but when we come to look closely at the widow and her dead son, she is a most moving figure, as Dante says, '*persona in cui dolor s'affretta*'. Beneath this allegory of humility are two figures of the proud, crawling on all fours under their heavy burdens, and they occupy the next Canto (XI); indeed Dante recognises one of them, the Bolognese miniaturist, Oderiso, whom he calls '*buon penello azzuro*'. So, thus early, a self-satisfied painter passes into great literature.

Later in the *Purgatorio* come those wonderful flame scenes [16], which are the setting for the lustful. 'The greatest artist of linear design'. Well,

3 Botticelli, *Paradise XXVIII: The Primum Mobile, c. 1495*

12 Botticelli, *Inferno XIX: The Simonists*, c. 1495

13 Botticelli, *Inferno XVII: Dante and Virgil with Geryon, c.* 1495

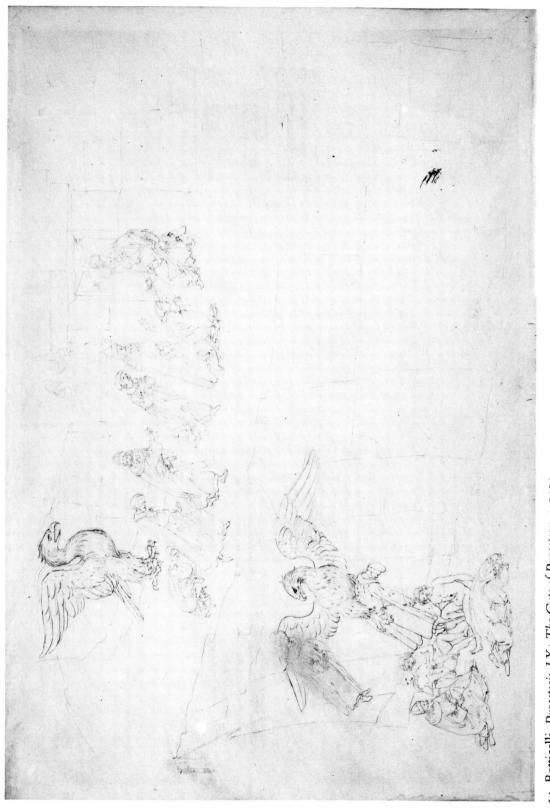

14 Botticelli, *Purgatorio I X : The Gate of Purgatory*, c. 1495

perhaps no other European could have entered with such delight into the movement of flames. It may be of interest to compare the living flames with the fourteenth-century version of the same scene, in which Virgil and Dante contemplate, without much emotion, some very formalised flames.

Finally, out of the flames, we come to one of the few drawings that everybody knows, when the poets, (accompanied by Statius) enter the divine forest 'thick and living' says Dante, but Botticelli makes it sparse and exquisite, of the Earthly Paradise [17]. They find a lady bending down to pick the flowers, whom Dante describes in lines that are amongst the most familiar in the *Commedia*, but I hope you will allow me the pleasure of quoting them:

> Giovane e bella in sogno mi parea
> donna vedere andar per una landa
> cogliendo fiori.

He steps forward and greets Matilda with the still more famous lines:

> Tu mi fai remembrar dove e qual era
> Proserpina nel tempo che perdette
> la madre lei, ed ella primavera.

Matthew Arnold, in an essay once widely read, attempted, by a choice of quotations, to establish the character of great poetry. He includes these lines as absolutely and unquestionably beautiful. Judged from the standpoint of pure poetry, we may agree with him; and he compares them with the lines of Milton, which are obviously inspired by Dante:

> Not that fair field of Enna, where Proserpine
> Gathering flowers, herself a fairer flower,
> By gloomy Dis was gathered.

Dante's lines have inspired Botticelli to execute the first completely beautiful drawing of the series.

There follow three of the most elaborate of the drawings, in which

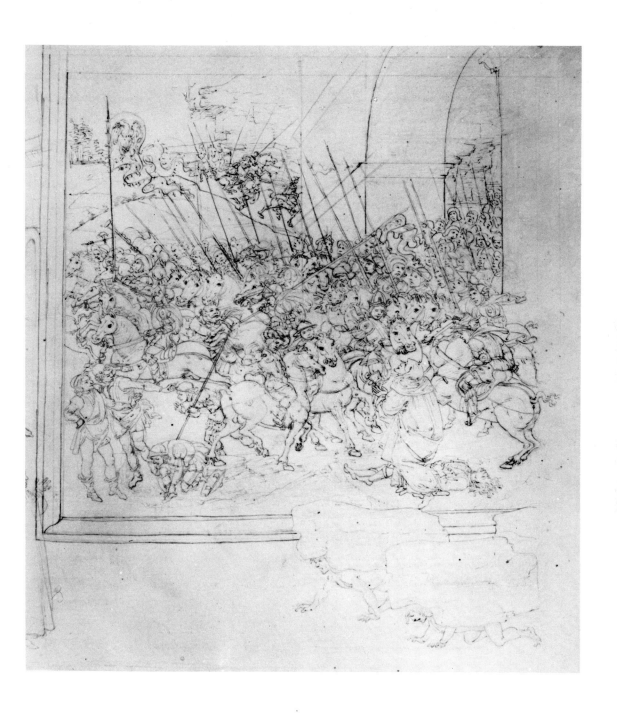

15 Botticelli, *Purgatorio X: The Proud* (detail of Trajan), *c.* 1495

Dante, Virgil and Statius are led by Matilda to witness the great procession of angels, church fathers and embodied virtues. Unfortunately an important part of the drawing has not been inked in, and the metal point is very faint—you see a cartwheel above and below the dancing angels. And, alas, my hopes of making them more visible by means of more sensitive methods of photography have so far been a failure. Then comes the great moment of the procession, when Beatrice appears, veiled and wreathed [18]. Dante casts down his eyes as she recounts his errors. He then confesses, but we are not shown the scene where his sins are washed away. Botticelli, with marvellous tact, gives Beatrice a severe countenance which is gradually modified as we come to the *Paradiso*.

The drawing which opens the *Paradiso* [19], like the encounter with Matilda at the end of the *Purgatorio*, is one of the two or three drawings in the series that is familiar to everyone, and deservedly so, for the floating movement of the two figures, Dante and Beatrice, as they rise out of the divine forest, is of a delicate and economical beauty unequalled in Western art. Never has the sense of spiritual ascent been more beautifully portrayed.

And now a very curious, and in some ways disappointing, development takes place. From Canto II to Canto XXII Botticelli concentrates almost entirely on the figures of Dante and Beatrice, isolated in a circle. To the medieval and renaissance mind the circle was the perfect form and as such plays a great part in the imagery of the *Divine Comedy*; but nowhere more than in the *Paradiso*, where every canto makes reference to it. So it is not surprising that Botticelli should make it the setting of Dante's long course of spiritual instruction. But visually it is a rather restricting ambience. Occasionally a few small attendants are added as auditors, as in the beautiful illustration to Canto III, where Beatrice addresses certain spirits who, through no fault of their own, have failed to keep their vows; and occasionally they are surrounded by flames. But Beatrice and Dante were always the dominant figures, and became an

obsession to him. The variations of their poses are a marvel of linear interplay, and their gestures communicate a sense of spiritual relationship. Consider this one, Canto V [20], in which Beatrice expounds to Dante the doctrine of the freedom of the will. With her beautiful feet pressed close together she floats in front of the poet, who raises his hand in admiration and astonishment. What could be finer than the contrast between her billowing draperies and Dante's severe outline?

Almost equally moving, in an entirely different mood, is the illus-tration to Canto XI [21], where Beatrice no longer admonishes severely, but points the way, and Dante looks at her with touching affection.

Throughout the whole series the relationship of the two figures is subtly varied, and each drawing by itself is of exquisite beauty. But I must confess that, when the theme has been repeated twenty times, I find my attention beginning to flag. We know from Giovanni di Paolo's illus-trations that the *Paradiso* contains plenty of images and legends which can be rendered visually. If only Botticelli had undertaken some of these subjects, for example the mystery of the Redemption, so beautifully illustrated by Giovanni di Paolo, how much richer we should be. Why didn't he? Herbert Horne believed that the *Paradiso* drawings were unfinished, but I am sure that this is a mistake. Botticelli felt, I believe, that the true subject of all these cantos was the spiritual and theological instruction imparted by Beatrice to Dante, and this could be conveyed only by concentrating on the two figures. To have included any other illustrative material would have been to deviate from the high purpose of the cantos.

At last, in the illustration to Canto XXI [22], there comes fresh action, where Beatrice shows Dante the ladder that leads to heaven, while the souls of those who have lived contemplative lives fly round them, 'like daws at daybreak, warming their feathers'. Dante faints at the thought of the ascent, and in a deeply moving drawing [23] Beatrice supports him and encourages him on his way.

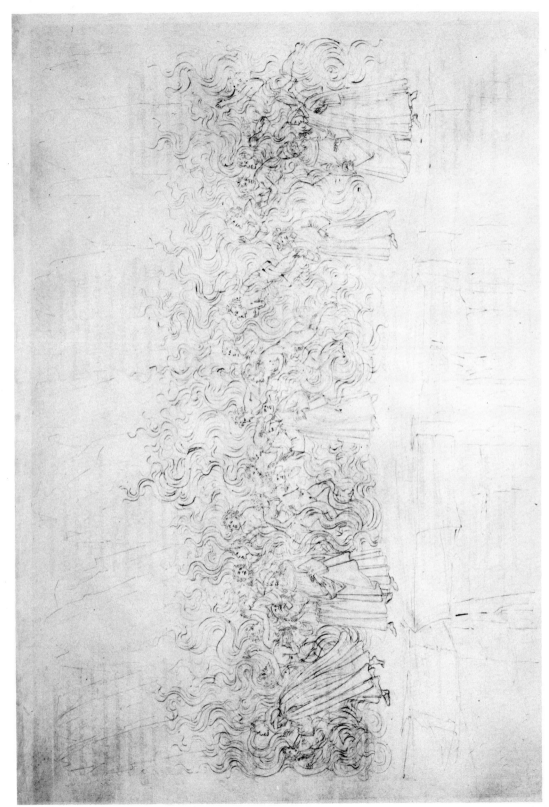

16 Botticelli, *Purgatorio XXVI: The Lustful* (detail of flames), *c.* 1495

17 Botticelli, *Purgatorio XXXIII: Dante and Beatrice at the stream of Eunöe, c. 1495*

18 Botticelli, *Purgatorio XXX: Beatrice in her Car*, c. 1495

19 Botticelli, *Paradiso I: The Ascent to Heaven, c.* 1495

20 Botticelli, *Paradiso V: Dante and Beatrice, c.* 1495

21 Botticelli, *Paradiso XI: The Sun*, c. 1495

22 Botticelli, *Paradiso XXI: Saturn, c.* 1495

23 Botticelli, *Paradiso XXII: Saturn, c.* 1495

There follow three cantos in which Dante averts his head and covers
his eyes in shame; then in Canto XXVII Beatrice tells him to raise his
head [24]; the clouds begin to clear and she leads him upwards. This is
one of the most moving of the illustrations, because it shows both Beatrice
and Dante in a mood of humility, prior to their flight. Then comes the
wonderful sheet where they are surrounded by a heavenly host—
'playing', says Dante, 'angelic games'. One may spend a long time
looking at these ravishing little figures before discovering that one of them
bears a tiny plaque on which are inscribed the words *Sandro di sua mano*
[25]. These flying figures remind us of the angels who surround and
celebrate the *Coronation of the Virgin* in the Uffizi—the picture that gave
Ruskin such transports of delight—and if scholars are right in dating it
1491, then we cannot be far from the date of the Dante drawings.
Another flight of Angels, and then, for Canto XXX, the last of the
finished, or rather of the half-finished drawings, for only a faint indication
of the stylus stroke is visible on the further side. They fly upwards over a
river of light, and on either side were two banks '*due rivi dipinti di mirabil
primavera*' with flowers of such beauty that Dante feels faint at their
brilliance and their perfume.

 This is the last drawing of the series to be more or less finished, and we
have no right to ask for more. Even Botticelli's imagination must have
been exhausted by the effort to make such high spirituality visible. But we
may selfishly grieve that he did not try to realise St Bernard's wonderful
hymn to the Virgin, which opens the last Canto:

> Virgine madre, figlia di tuo figlio
> Umile ed alta piu che creatura.

That vision of the Madonna which Botticelli, more than any other artist,
perhaps, has fixed in our imagination, would have made a most moving
close to the series. Was he exhausted; or did he shrink from so great a
responsibility? Or is the sheet simply lost?

24 Botticelli, *Paradiso XXVII: The Ascent to the Primum Mobile*, c. 1495
25 Botticelli, *Paradiso XXVIII: The Primum Mobile* (detail of inscription), c. 1495

There are many reasons why Botticelli's illustrations to Dante have a value to us greater than any others that have survived: they are the work of a serious student of the poet, working in company with the second generation of expositions of his work. They represent what the commentators of the fifteenth century believed to be Dante's meaning. They are also the work of a supremely great draughtsman. When I used the words 'have survived' I was thinking of the tradition that Michelangelo, who was also a profound student of Dante, did a series of illustrations to the *Purgatorio* in the margins of a large folio of the *Divine Comedy*. The earliest reference to this tradition that I can find is in a letter dated 1747 from Bottari, editor of the first collection of artists' letters, to his friend Gori. It is repeated, without any references, in a footnote to Vasari's life of Michelangelo in the Milanesi edition of 1881. 'This precious volume' he says, 'passed into the possession of Antonio Montauti, who sent it with the rest of his goods from Livorno to Civitavecchia, but the ship was wrecked, and the volume lost.' Michelangelo is known to have studied Dante throughout his life, and there are undoubtedly echoes of the *Inferno* in the *Last Judgement* of the Sistine Chapel. What an inestimable treasure his marginal illustrations to the *Purgatorio* would have been! But I fear that the whole story has the character of a legend.

And with a legend it may be concluded. One day in the late '90s York Powell, the learned and intelligent Regius Professor of History at Oxford met Logan Pearsall Smith in a 'bus in a high state of excitement, saying that he had discovered the volume in Christ Church Library. Logan immediately informed Berenson, who was then finishing his book on Florentine drawings, and the Berensons came over immediately. It is always difficult to find a book in a large uncatalogued library, and they did not succeed. It has occurred to me that York Powell was talking about the two remarkable illustrations to Dante by Ligozzi, and may have said something of their possible relationship with Michelangelo which Logan misunderstood. Or he may simply have been romancing.

I have given some reasons why I believe Botticelli's drawings to be the finest illustrations to Dante. But I cannot end without saying that in my opinion they are almost equalled by the Dante illustrations of William Blake. Blake was far removed from the traditional imagery of Dante's time, and from the first commentators; and of course he could not command the wonderful firmness and certainty of Botticelli's drawing. Instead of the *buon disegno* of the Florentine *quattrocento*, he was heir to the equivocations of late eighteenth-century mannerism. But Blake was a man of the highest poetic genius. Although he abominated Dante's doctrines, he recognised him as a supreme poet. 'Whatever Book is for Vengeance for Sin', he wrote on one of the drawings of the *Inferno* 'and whatever Book is Against the Forgiveness of Sins is not of the Father, but of Satan the Accuser'. As W. B. Yeats said, 'As Blake sat over his great drawing book he was very certain that he and Dante represented spiritual states which face one another in an eternal enmity'. Yet he could not resist the power of Dante's visions. He said to Samuel Palmer, who found him sitting up in bed, working on the Dante drawings, that he had 'begun to do them in fear and trembling'. They are the greatest drawings he ever did, and when one compares them with the passages in Dante they illustrate, one finds an imaginative insight, yes, and occasionally an understanding of Dante's text, more complete than that of Botticelli. This is partly because Blake's vision was not complicated by the far-fetched interpretations of commentators, but went straight to Dante's own words, based partly on Cary's translation and partly on the original Italian which Blake had learnt at the age of 67. Until Mr Roe's book of 1953, Blake's drawings were looked at simply as beautiful works of decorative art, and so they are. But they are much more, and I take as my examples two relatively unfinished Blakes, and compare them with two of Botticelli's most highly worked-out drawings. One of them is the incident in *Purgatorio* Canto X, where Virgil and Dante see the proud under their enormous loads. Botticelli shows them mounting a zig-zag path.

But Blake's imagination immediately siezes upon Dante's marvellous simile—they move through a cloven mass of stone, which moves from one side to the other like a wave '*si come l'onde che fugge e s'appresa*'. Surely Blake's drawing is closer to Dante's vision.

The second instance is the supreme moment, when Dante first sees Beatrice in her car [26]. In Botticelli's drawing she is almost hidden by the number of her attendants, angels, elders, church fathers. In Blake's unfinished design her place in the horned chariot gives her a mysterious divinity. Moreover, Blake has been careful to preserve a feature frequently referred to by Dante, the shining river that runs between himself and Beatrice. There are many other features in the Blake drawing that do not occur in the Botticelli, and yet seem to be an essential part of Dante's vision. Although Blake's drawings penetrate so deeply into the world of Dante's imagination, they lack two qualities which are essentially Dant-esque: purity and economy. The way in which Dante, both in his descriptions and his moral judgements, combines vividness with economy is one of the first things to impress every reader of his great poem. They may consist of only three or six lines, and yet they reveal to us a whole landscape or searching piece of human insight. Such concen-tration was foreign to the romantic plethora of Blake's style, and he achieves it almost, as it were, accidentally in some unfinished drawings. An example is the illustration to Inferno XXIII [27]. 'They had cloaks on with deep hoods over their eyes, such as they make for the monks of Cologne.' Botticelli, by the controlled simplicity of his style, arrives at something of Dante's purity of diction, and we return to his drawings with a kind of relief, as of one who has disencumbered himself of too grievous a load of baggage.

26 Blake, *Purgatorio XXIX: Beatrice on the Car, Dante and Matilda*, 1824–27
27 Blake, *Inferno XXIII: The Hypocrites with Caiaphas*, 1824–27

LIST OF PLATES

DONATELLO

1 Lorenzo Ghiberti, *Abraham sacrificing Isaac*. Bargello, Florence *page* 10
2 Filippo Brunellesco, *Abraham sacrificing Isaac*. Bargello, Florence 13
3 Lorenzo Ghiberti, *Jacob and Esau*. Gates of Paradise, Baptistry, Florence 14
4 Donatello, *St Mark*. Or San Michele, Florence 15
5 Donatello, *Zuccone*. Or San Michele, Florence 17
6 Donatello, *Feast of Herod*. Baptistry, Siena 18
7 Donatello, *Ascension with Christ giving the Keys to St Peter*. Victoria and Albert Museum, London 21
8 Donatello, *Miracle of the Ass*. S. Antonio, Padua 23
9 Donatello, *Miracle of the Irascible Son*. S. Antonio, Padua 23
10 Donatello, *Entombment*. S. Antonio, Padua 25
11 Donatello, *St John the Baptist*. Sta Maria Gloriosa dei Frari, Venice 27
12 Donatello, *Mary Magdalene*. Baptistry, Florence 29
13 Donatello, *Mary Magdalene* (profile) 30
14 Donatello, *Judith and Holofernes*. Piazza della Signoria, Florence 30
15 Donatello, *Judith and Holofernes* (detail) 31
16 Donatello, *Lamentation over the Dead Christ*. Victoria and Albert Museum, London 33
17 Donatello, *Descent into Limbo*. S. Lorenzo, Florence 35
18 Donatello, *Ascension*. S. Lorenzo, Florence 35
19 Giovanni Bellini, *Dead Christ raised from the Tomb*. Kupferstichkabinett, Staatliche Museen Preussicher Kulturbesitz, Berlin (West) 37
20 Giovanni Bellini, *Pieta*. Brera, Milan 38
21 Giovanni Bellini, Pesaro altarpiece. Museo Civico, Pesaro 39
22 Francesco di Giorgio, *Flagellation*. Galleria Nazionale dell'Umbria, Perugia 41

PAOLO UCCELLO

1 Villard de Honnecourt, Folio 19: *Sketchbook*. Bibliothèque Nationale 45
2 S. Miniato al Monte, Florence, detail of choir screen 45
3 Giovanni di Paolo, *Birth of John the Baptist*. Westfälisches Landesmuseum für Kunst und Kulturgeschichte Münster; Dauerleihgabe des Westfälisches Kunstvereins 47

4 Jan van Eyck, *Madonna and Child with Chancellor Rolin*. Louvre, Paris 49
5 Milanese cassone with perspective views. Staatliche Kunstsammlungen, Dresden 50
6 After Piero della Francesca, *Perspective View of an Ideal City*. Galleria Nazionale
 delle Marche, Urbino 50
7 Luca Pacioli, Letter A from *Divina proportione* British Library, London 53
8 Piero della Francesca, Regular body from *Cinque Corpi Regolari*. Vatican
 Library, Rome 53
9 Uccello, *Equestrian Monument to Sir John Hawkwood*. Duomo, Florence 56
10 Uccello, *Study for the Hawkwood Monument*. Uffizi Gallery, Florence 57
11 Uccello, *Deluge*. Chiostro Verde, Sta Maria Novella, Florence 59
12 Uccello, *Deluge* (detail) 59
13 Uccello, *Drawing of a mazzochio*. Uffizi Gallery, Florence 60
14 Piero della Francesca, Drawing of a mazzochio from *De Prospettiva Pingendi* ...
 Biblioteca Palatina, Parma 60
15 Daniele Barbaro, Drawing of a mazzochio from *La Practica della perspettiva* ...
 British Library, London 60
16 Uccello, *Rout of San Romano*. National Gallery, London 62
17 Uccello, *Rout of San Romano*. Uffizi Gallery, Florence 62
18 Uccello, *Rout of San Romano*. Louvre, Paris 63
19 Florentine engraving, *Wild animals attacking horses and oxen. c.* 1460 64
20 Uccello, *Rout of San Romano* (detail). National Gallery, London 67
21 Uccello, *Rout of San Romano* (detail). Uffizi Gallery, Florence 68
22 Uccello, *Rout of San Romano* (detail). Louvre, Paris 69
23 Uccello, *A Hunt in a Forest*. Ashmolean Museum, Oxford 71
24 Uccello, *St George and the Dragon*. Musée Jacquemart-André, Paris 71
25 Seurat, *Baignade*. National Gallery, London 74
26 Seurat, *Sunday Afternoon on the Island of la Grande Jatte*. Courtesy of the Art
 Institute of Chicago 77

LEON BATTISTA ALBERTI

1 Leon Battista Alberti, *Self-Portrait Plaque*. Kress Collection, National Gallery of
 Art, Washington 78
2 Masaccio, *Tribute Money*. Brancacci Chapel, Sta Maria del Carmine, Florence 85
3 Masaccio, *St Peter distributing Alms*. Brancacci Chapel, Sta Maria del Carmine,
 Florence 85

4 Luca della Robbia, *Cantoria*. Museo dell'Opera del Duomo, Florence 87
5 Giovanni da Ponte, *Altarpiece*. National Gallery, London 89

ANDREA MANTEGNA

 1 Mantegna, *St James addressing the Demons*. Ovetari Chapel, Eremitani Church, Padua 106
 2 Mantegna, *Baptism of Hermogenes*. Ovetari Chapel, Eremitani Church, Padua 111
 3 Mantegna, *St James led to Execution*. Ovetari Chapel, Eremitani Church, Padua 113
 4 Mantegna, Drawing for *St James led to Execution*. Department of Prints and Drawings, British Museum, London 115
 5 Mantegna, *Martyrdom of St Christopher*. Ovetari Chapel, Eremitani Church, Padua 118
 6 Mantegna, *Martyrdom of St Sebastian*. Louvre, Paris 121
 7 Mantegna, *Martyrdom of St Sebastian*. Cà d'Oro, Venice 122
 8 Mantegna, *Madonna and Child*. Gemäldegalerie, StaatlichMuseen Preussicher Kulturbesitz, Berlin (West) 125
 9 After Mantegna, *Battle of the Sea Gods*. Department of Prints and Drawings, British Museum, London 126
10 Mantegna, *Mars between Venus and Diana*. Department of Prints and Drawings, British Museum, London 127
11 Mantegna, *Ludovico Gonzaga, His Family and Court*. Camera degli Sposi, Palazzo Ducale, Mantua 129
12 Mantegna, *Arrival of Cardinal Francesco Gonzaga*. Camera degli Sposi, Palazzo Ducale, Mantua 131
13 Mantegna, *Ceiling decoration with bust of the Emperor Tiberius*. Camera degli Sposi, Palazzo Ducale, Mantua 133
14 Mantegna, *The Triumph of Caesar: The Corselet Bearers*. Hampton Court Palace. Reproduced by gracious permission of Her Majesty the Queen 137
15 Mantegna, *Self-Portrait Bust*. S. Andrea, Florence 139

SANDRO BOTTICELLI

 1 Bandini after Botticelli, *Inferno XIX*. British Library, London 145
 2 Botticelli, *Mystic Nativity*. National Gallery, London 146

3 Botticelli, *Paradiso XXVIII*. Staatliche Museen zu Berlin (East) 158

4 Botticelli, *Virgin and Child with Angels*. Galleria Ambrosiana, Milan 149

5 Chantilly manuscript, *Inferno XV*. Musee Condé, Chantilly 151

6 *Inferno XVII*. British Library, London 151

7 *Inferno XXII*. British Library, London 152

8 *Inferno XXXI*. British Library, London 152

9 Guglielmo Giraldi, *Inferno IX*. Vatican Library, Rome 154

10 Vecchietta?, *Inferno V*. British Library, London 155

11 Giovanni di Paolo, *Paradiso VII*. British Library, London 155

12 Botticelli, *Inferno XIX*. Kupferstichkabinett, Staatliche Museen Preussicher Kulturbesitz, Berlin (West) 159

13 Botticelli, *Inferno XVII*. Kupferstichkabinett, Staatliche Museen Preussicher Kulturbesitz, Berlin (West) 160

14 Botticelli, *Purgatorio IX*. Staatliche Museen zu Berlin (East) 161

15 Botticelli, *Purgatorio X*. Staatliche Museen zu Berlin (East) 163

16 Botticelli, *Purgatorio XXVI*. Staatliche Museen zu Berlin (East) 166

17 Botticelli, *Purgatorio XXXIII*. Staatliche Museen zu Berlin (East) 167

18 Botticelli, *Purgatorio XXX*. Staatliche Museen zu Berlin (East) 168

19 Botticelli, *Paradiso I*. Staatliche Museen zu Berlin (East) 169

20 Botticelli, *Paradiso V*. Staatliche Museen zu Berlin (East) 170

21 Botticelli, *Paradiso XI*. Staatliche Museen zu Berlin (East) 171

22 Botticelli, *Paradiso XXI*. Staatliche Museen zu Berlin (East) 172

23 Botticelli, *Paradiso XXII*. Staatliche Museen zu Berlin (East) 173

24 Botticelli, *Paradiso XXVII*. Staatliche Museen zu Berlin (East) 175

25 Botticelli, *Paradiso XXVIII*. Staatliche Museen zu Berlin (East) 175

26 William Blake, *Purgatorio XXIX*. Department of Prints and Drawings, British Museum, London 179

27 William Blake, *Inferno XXIII*. Tate Gallery, London 179

ACKNOWLEDGEMENTS

My thanks are due to the Curators of the Galleries and Museums who have kindly given permission to reproduce illustrations and have supplied prints, and to the following for photographs: Alinari, Donatello 1, 2, 3, 4, 5, 6, 8, 9, 10, 11, 12, 13, 14, 15, 17, 18, 19, 20, 21, 22; Uccello 6, 9, 10, 11, 12, 17, 21; Alberti 2, 3, 4; Mantegna 1, 2, 3, 5, 7; Botticelli 4: Deutsche Fotothek, Uccello 5: Giraudon, Uccello 4, 18, 22, 24; Mantegna 6; Botticelli 5.

INDEX

abstract art 43, 44, 73, 92
Adoration of the Shepherds (Botticelli) 147
Adoration of the Magi (Gentile da Fabriano) 16, 84
Alberti, Leon Battista 48, 54, 66, 79–83, 84–105, 109; on colour 98–9; drapery 96, 99, 101, 103; the nude 96, 99; subjects 55, 94–5, 96
Altarpiece (Giovanni da Ponte) 86
Altichiero 108
Andrea del Castagno 24, 96, 110
Angelico, Fra 20, 22, 42, 88, 99
Ansuino da Forli 117
antiquity: Mantegna and 107, 112–14, 116, 117, 119, 120, 123, 130, 132, 136–8, 140; Renaissance discovery of 94, 97, 107, 112–114
Antonine, St 26
Antonini, The (Donatello) 24, 65, 108
Apollonio di Giovanni 112
Appian 138
Après-Midi à la Grande Jatte (Seurat) 73, 75
Architettura 98
Aristotle 82, 105, 107
Arnold, Matthew 162
Arte di Calimala 12
Ascension (Donatello) 34
Ascension and Delivery of the Keys (Donatello) 20
Ashburnham Codex 101
Attila (Raphael) 157

Bacchanals (Mantegna) 124
Bacon, Francis 94
Baignade (Seurat) 73
Baker, Collins 135–6
Bandini, Baccio 144, 153, 156
Barbaro, Daniele 61
Bassano, Jacopo 95, 103

Battle pictures (Uccello) 65–70, 73, 75
Battles of Sea Gods (Mantegna) 124
Beckford, William 145
Belle Haulmière (Rodin) 28
Bellini, Giovanni 36, 40, 42
Bellini, Jacopo 42, 110, 116
Benedetto da Majano 22
Berenson, Bernard 141, 147, 148, 176
Berlin 142; *Kupferstichkabinett* 145; Berlin Gallery 123
Betrayal fresco (Giotto) 11
Bicci workshop 84
Biondo, Michelangelo 105
Birth of Venus (Botticelli) 142, 143
Bisticci, Vespasiano de' 90n
Blake, William 177–8
Bona da Ferrara 117
Botticelli, Sandro 36, 42, 61, 96, 104, 124; Dante illustrations 141, 144–79; reputation 142–3
Braque, Georges 43
Brealey, John, restorer 136
Brunellesco, Filippo 79, 84; Baptistry door 12, 83; and Donatello 22, 51; perspective 46, 48–51, 116, 117, 119
Bruni, Leonardo 22, 52

Calumny of Apelles (Botticelli) 147
Camera Depicta (Camera dei Sposi), Mantua (Mantegna) 124–32
camera obscura 80–1
Caracci family 100, 102
Carlyle, Thomas 82
Carrara family 107
Carteggio (Gaye) 88n
cassoni 36
Castagno, *see* Andrea del Castagno
Castiglione, Baldassare 132

Cennini, Cennino 90
certezze 43–4, 48, 51, 70
Chantilly *Inferno* 148
Charles I, King of England 135
Christina, Queen of Sweden 144, 145
Christ supported by two Angels (Mantegna) 123
Cinque Corpi Regolari see Five Regular Bodies
classical art: Alberti and 80, 94–5, 97–8, 102;
 Mantegna and 120, 134–8; Uccello and 103
Codex Escurialenses 114n
Commedia Divina, La see Divine Comedy
Commentarii (Ghiberti) 90
Copenhagen 123
Coronation of the Virgin (Botticelli) 142, 174
Cortegiano (Castiglione) 132
costruzione legittima 51
Creation fresco (Uccello) 102
Crucifixion (Andrea del Castagno) 24
Cubism 70, 75
Cyriac of Ancona 132

Dahlem 142
Dante Alighieri 22; *Divine Comedy* 11, 141,
 143–4, 147–8, 150, 156, 162, 164, 174,
 176–8
David (Donatello) 26, 28
David (Michelangelo) 19
Dead Christ, The (Mantegna) 61, 140
Dead Christ raised from the Tomb (Bellini) 36
Dead Christ supported by the Virgin and St John
 (Bellini) 36
de Iciarchia (Alberti) 104
Delacroix, Eugène 42
della Pittura (Alberti) 55, 79, 82, 83, 86–96,
 98–105
Deluge, The (Uccello) 55–65, 66, 72, 73,
 102–3
De Re Aedificatoria 55
Descent into Limbo (Donatello) 34
Desiderio 104
Divine Comedy (Dante) 147–8, 150–3, 157,
 162, 164, 176
Domenico Veneziano 88, 96, 99
Donatello 24–42, 58, 65, 84, 86, 97, 104, 108;
 and Alberti 80, 81, 83; and Brunellesco 22;

influence of 36–42, 110, 114–16; influences
 on 12, 51; and Mantegna 36, 40, 114–116;
 and Masaccio 20–2; prophets 16–20; S.
 Lorenzo pulpits 32–6
Dürer, Albrecht 48, 91, 108, 120

Entombment (Donatello) 26
Epistle pulpit (Donatello) 34
Este, Isabella d' 138
Expulsion of Adam and Eve from Paradise
 (Donatello) 20
Eyck, Hubert van 48
Eyck, Jan van 48

Feast of the Gods (Bellini) 110
Feast of Herod (Donatello) 19, 84
Federigo of Urbino 42
Ferrara 117
Ficino, Marsilio 104
Fileefo, Francesco 80
Five Regular Bodies (Piero della Francesca 44,
 46, 52
Flagellation (Francesco di Giorgio) 40–42
Flemish art 46–8, 72
Florence: Annunziata 105; Arena Chapel 11;
 Baptistry 12–16, 28, 83, 84; Brancacci
 Chapel 20, 102; Duomo 16, 54, 66, 86, 108;
 Medici Palace 65, 72; Or San Michele 16,
 19, 20; Piazza della Signoria 28; Rucellai
 Palace 105; S. Apollonia 24; S. Lorenzo
 22, 32–6, 41, 116; San Marco 88; Sta Maria
 del Carmine 20, 42, 83n, 86, 94, 128; Santa
 Maria Novella 102, 105; S. Miniato 65; S.ta
 Trinita 16; Tempio Malatesta 104; Uffizi
 65, 66, 99, 109, 174
Florentine art 11, 12, 20, 22, 36, 44, 70–2, 84,
 91, 104
Florentine Painters (Berenson) 141
Florentine science 43–6, 48, 52
Fortnightly Review 142
Francesco di Giorgio 40–42, 83n
Francesco di Pistoja 97
Fry, Roger 135

Gaddiano, Anonimo 143

Garda, Lake 132
Gentile da Fabriano 16, 20, 84, 110
geometry and art 44–6, 52, 55, 61, 75, 86, 90
Gerini workshop 84
Ghiberti, Lorenzo 86, 90, 95; Baptistry doors
 12, 26–8, 54, 83–4, 97, 110; style 12–16, 84,
 114
Ghirlandaio, Domenico 22, 97
Giotto 11–12, 20, 22, 42, 84, 86, 103, 148
Giovanni di Francesco 73
Giovanni di Paolo 19–20, 46, 153, 165
Giovanni da Ponte 86
Giraldi, Guglielmo 150
Gonzaga, Cardinal Francesco 128–30, 132,
 135, 138
Gonzaga, Ludovico Duke of Mantua 123,
 124, 128, 135
Gosse, Sir Edmund 143
Gothic style 65, 70–2, 84, 92, 102, 103, 114,
 120, 134; and geometry 54; international 16;
 perspective 46
Grassi, Giovanni de' 114n
Gris, Juan 43

Hamilton Palace 142
Hampton Court 134, 136
Hawkwood, Sir John 55, 88n
Hellenistic art 116
Holbein, Hans 91
Holland, art 42
Horne, Herbert 165
humanism 58, 80, 83, 107, 108, 110–12, 138
Hunt in a Forest (Uccello) 72, 103

illusionist perspective 116, 117, 130, 136
Impressionism 75
Inferno (Dante) 11, 144–7, 148–50, 153,
 156–7, 176, 177, 178
intarsie 52
international Gothic style 16

Jones, Inigo 123, 135
Jonson, Ben 135
Judith and Holofernes (Donatello) 28–32
Justice of Trajan (Botticelli) 157

Keats, John 22, 134

Laguerre, Louis 135
Lamentation over the Dead Christ (Donatello) 32
Landino, Cristoforo 144, 153
Last Judgement (Giotto) 148
Last Judgement (Michelangelo) 176
Lebrun, Charles 123
Leonardo da Vinci 51, 61, 95, 100–2, 105
Ligozzi 176
Lippi, Filippino 36, 94, 96
Lippi, Fra Filippo 20, 22, 41, 72, 88, 108, 109
Lippmann, Dr F. 141, 145
Livy 107
London: British Library 148, 150; British
 Museum 110, 124; National Gallery 65, 66,
 70, 75, 147; Victoria and Albert Museum
 20, 32, 42n, 114
Lorenzo di Credi 55
Lorenzo Monaco 12, 92
Luca della Robbia 22, 42, 83, 86
Lucian 82

Madonna (Mantegna) 123
Malatesta, Sigismondo 104
Manetti, Gianozzo 22, 51, 144, 153
Mantegna, Andrea 61, 107–40; and antiquity
 107, 112–14, 116, 117, 119, 120, 123, 130,
 132, 136–8, 140; and Donatello 36, 40,
 114–16; at Mantua 123–32, 135; and Piero
 della Francesca 117–19
Mantua: Camera Depicta 124–32; Court of
 123, 124, 128, 132
Mars between Venus and Diana (Mantegna) 124
Martyrdom of St Christopher (Mantegna) 117,
 119
Martyrdom of St Sebastian (Mantegna) 120–3
Masaccio 20–2, 42, 58, 66, 81, 83, 84, 86, 88,
 91, 94, 95, 99, 102, 104, 128; influences on
 20, 51; perspective 48
Maso di Bartolommeo 83n
Masolino da Panicale 20, 102
mathematics and art, 43–8, 51–2, 54, 70, 84,
 90–1, 93, 99
Matteo de' Pasti 83n

mazzochio 58–61, 66
Medici family 65
Medici, Cosimo de' 28, 32, 90; Lorenzo de'
 104, 105, 143, 147; Lorenzino 143, 147;
 Pietro de' 88n
Meninas, Las (Velasquez) 128
Michelangelo Buonarotti 16, 19, 42, 123, 143,
 176
Milan: Ambrosiana Gallery 147; Brera 36, 61,
 140
Milanesi, 145, 176
Milton, John 140, 162
*Minerva expelling the Vices from the Groves of
 Virtue* (Mantegna) 138
Miracle of the Ass (Donatello) 24
Miracle of the Irascible Son (Donatello) 24
Miracles of St Anthony (Donatello) 114
Molini, Claudio 144
Monaco, Lorenzo *see* Lorenzo
Montauti, Antonio 176

Nash, Paul 135
naturalism 43, 48, 51, 54, 55, 66, 75, 86
'Navicella' (Giotto) 103
Neroccio de' Landi 40
Niccoli, Niccolò 80, 90, 97
North, Kennedy 136

Oderiso 157
Of Divine Proportion (Pacioli) 43–4, 52
Opinioni 43, 48
Orfeo (Poliziano) 135
Orvieto 153
Oxford: Ashmolean Museum 108n

Pacioli, Luca 43–4, 52, 55
Padua 107–8, 132; Arena chapel 148;
 Donatello in 22, 24–6, 36, 65, 108, 114;
 Gattamelata 22, 108; Ovetari Chapel,
 Eremitani Church 109, 110, 114, 117, 119,
 136; Santo 19, 24–6, 36, 40, 65, 108, 114
Palmer, Samuel 177
Paradiso (Dante) 11, 141, 144, 147, 150, 153,
 164–74
Paris: Jacquemart-André Museum 73, 119;

Louvre 65, 66, 75, 83n, 110, 120
Parnassus (Mantegna) 138
Pater, Walter 142
pattern books 114, 116
Paul III and his nephews (Titian) 128
Pearsall Smith, Logan 176
perspective 44, 109; Brunelleschian 46, 48–51,
 54, 70, 116, 117, 119; development of
 46–51, 110, 130; Gothic 46, 72; illusionist
 116, 117, 130, 136; Uccello's 54, 61–5,
 72–3, 110
Perugia 40
Pesaro altarpiece (Bellini) 36
Pesellino, Francesco 36, 65
Petrarch 107, 135, 136
Piazzuola 107
Pico della Mirandola 104
Piero della Francesca 51, 73, 88, 132; and
 Alberti 99, 102, 104; and Mantegna
 117–19; mathematics 44, 46, 48, 52
Pini, Paolo 105
Pizzolo 109
Plato 52, 82, 93, 99, 104, 107
Pliny 82, 90, 94
Plutarch 82
Poggio 80, 97
Politian 104
Poliziano, Angelo 135
Pollaiuolo, Antonio 40, 66, 96
Pope-Hennessy, John 19, 153
Poussin, Nicholas 102
Powell, York 176
Priamo della Quercia 153
Primavera (Botticelli) 124, 142, 143
proportion, harmonious 52
prospettiva 70
Prussian Jahrbuch (1915) 61
Purgatorio (Dante) 11, 141, 150, 153, 156–64,
 176, 177–8
Pythagoras 46, 52, 70

Quintilian 82

Raphael 20, 95, 96, 97, 99, 123, 143, 157
Ravenna 112

realism 51, 92, 94
Rembrandt van Rijn 19, 42
restoration 124, 128, 130, 135, 136
Reynolds, Sir Joshua 93
Richter, I. A. 101n
Rimini 114
Rodin, Auguste 28
Romano, Giulio 98
Rome 114, 134, 135, 138; Arch of Titus 138;
 St Peter's, Stefaneschi altarpiece 11–12;
 Tabernacle 80; Sistine Chapel 176; Vatican
 144, 145
Rossellino, Bernardo 22
Rossetti, D. G. 142
Ruskin, John 134, 142–3, 174

Sacchetti, Franco 12
Sagra (Masaccio) 128
St George (Donatello) 19
St George and the Dragon (Uccello) 73
St James addressing the Demons (Mantegna) 109
St James Baptising (Mantegna) 109, 110
St James before Herod (Mantegna) 110–12, 116
St James led to Execution (Mantegna) 40, 112,
 116, 130
St John the Baptist (Donatello) 26, 28, 36
St Mark (Donatello) 16, 19, 26
St Mary Magdalene (Donatello) 28
Salome (Donatello) 116
Samuele da Tradate 132
Savonarola 26, 147
scientific naturalism 86, 99, 103
Seurat, Georges 43, 58, 73
Siena 36, 40, 46; Baptistry 19; Cathedral 32
Signorelli, Luca 153
Simon *Madonna* (Mantegna) 123
Smith, Logan Pearsall *see* Pearsall
Solomon and the Queen of Sheba (Ghiberti)
 95
Squarcione, Francesco 107, 108, 109
Stefaneschi altarpiece (Giotto) 11–12
studio pattern books 114, 116
Strzygowski, Joseph 145
Suetonius 138
Swinburne, A. C. 142

Timaeus (Plato) 52
Tintoretto, Jacopo Robusti 142
Titian 42, 112, 128
Toscanelli, Paolo 86
Tradescant's Ark 108
Trattato della Pittura (Leonardo) 100–2
Tribute Money (Masaccio) 20
Triumph of Caesar (Mantegna) 124, 135–8
Tuscan art 44, 84

Uccello, Paolo 22, 43, 54–76, 88, 102–3, 108,
 110
Urbino: Corpus Domini 72; Library 150;
 Palace 51, 132

Vasari, Giorgio 176; on Alberti 80, 103;
 Botticelli 142, 144, 145; Brunellesco 86;
 Donatello 19, 22, 32, 97n, 108; Mantegna
 117, 119; Uccello 58, 61, 65
Vecchietta 153
Velasquez, Diego 128
velo 91
Venice 110, 112; Cà' d'Oro 120; Carmine
 42; Donatello in 26; Frari church 26, 28; St
 Mark's 54; San Rocco 142
Verona, S. Zeno 119–20, 124
Vienna 120
Villard de Honnecourt 44, 54
Virgin and Child with Angels (Botticelli) 147
vision, science of 90–1, 92–3

Waagen, G. F. 145
Whitehead, Professor 94

Yates Thompson Dante ms 150–3
Yeats, W. B. 177

Zuccaro 156
Zuccone (Donatello) 16, 26